D1277615

MINNESOTA
Memories *&* Images

by Michael Peterson

Dedication

To my family who has supported and encouraged me—
They make it possible.

Book and Cover Design by Jonathan Norberg

Copyright 2003 by Michael Peterson
ISBN 1-59193-013-8
Published by Adventure Publications, Inc.
820 Cleveland St. S
Cambridge, MN 55008
1-800-678-7006
All rights reserved
Printed in China

MINNESOTA

Memories *&* Images

About the Author

Photography for Michael Peterson began as a hobby, but quickly grew to become his livelihood. His photographs have appeared in exhibitions around the country, and several have won juried art shows. In December of 1999, he opened Wild Light Gallery in Walker, Minnesota. Mike and his family live in the Lake Country of Northern Minnesota. Stop by his gallery if you'd like to know more about him.

About Minnesota

Minnesota has many claims to fame that its people will gladly and proudly share. Much of the state's charm is its wide variety of scenic splendor, which changes dramatically from border to border. Minnesota's landscape greatly varies; gracing the land are wide prairies, river valleys, dense forest, rolling bluffs and the glittering skyline of Minneapolis-St. Paul. Calling itself "The Land of 10,000 Lakes" is a modest understatement. There are close to 15,000 sparkling lakes serving as the playground for Minnesotans' favorite pastimes–fishing, snowmobiling and hockey. The headwaters of the Mississippi are found in Itasca State Park. Its beginnings could be mistaken for a no-name creek, but gains immense width and volume, making the Mississippi River one of the largest waterways in the world.

The people here have an intimate connection to the past; they recognize the extent to which the people who lived before them have influenced many aspects of their lives today. The entire state is riddled with historical sites and monuments that lend greater understanding of the ethnic heritage, industrial advances and events that have shaped Minnesota since before it was even a state. The Glockenspiel in New Ulm was replicated from the original in Germany, and Big Ole in Alexandria holds a shield claiming Minnesota as the "Birthplace of America." Places like Ironworld and the Minnesota History Center have extensive genealogical resources. Glensheen Mansion is an example of how the significance of history was identified before it was even history; it was the owners' intentions that the

entire estate and all its furnishings be preserved for and donated to the public, to be appreciated for years to come. Pipestone National Monument is a priceless treasure of Native American History. The United States Hockey Hall of Fame in Eveleth, and the Minnesota Fishing Hall of Fame in Walker are meccas to which hockey and fishing enthusiasts flock to pay homage to the pioneers and former superstars of their sports.

The state is a haven for the arts. The Minneapolis Institute of Arts and the Ordway Center for the Performing Arts make up a fraction of entities in Minnesota that connect people to the world's culture. The Twin Cities, one of the nation's best arts communities, is home to a number of museums, dance and music companies, and over half of the 400 professional and community theaters statewide. The metro area has more concert venues per person than any other city in the country, except New York. Tucked up in the corner of the state is Grand Marais, home to the arts community inspired by the human reaction to the North Shore. Other oases for the arts are Lanesboro and New York Mills, both ranked among the "100 Best Small Arts Towns in America," according to the Minnesota State Arts Board.

There is an undisputed connection between Minnesota's people and nature. There are 72 state parks and recreation areas, over one thousand wildlife management areas holding 1.1 million acres, and 135 Scientific and Natural Areas that are protected and visited year-round. The Boundary Waters Canoe Area Wilderness is one of the nation's favorite sanctuaries. Voyageur's National Park is a water-

based park situated on the Minnesota-Canadian border. The many state parks give visitors the chance to experience a break from modernity, to see many native plants, birds and wildlife, and to live the rustic life, toughing it out in the wilderness.

But Minnesotans have nothing to prove when it comes to "toughing it out" in the elements. Visitors who have never faced a winter in this state often underestimate how low the mercury will actually drop. Then, they have to factor in wind chill. Half the year sees snowfall and the other half serves up a mix of balmy, crisp, muggy and stormy weather. The climate affects no one as much as the farmer, whose livelihood is dependent on a gamble. But they have the ability to sow seeds on some of the best soil in the world, which has been the one constant they can bet on.

This book celebrates a sampling of the things that make Minnesota a place that endures in the memory. It is organized into these six sections: Prairie Grasslands, Lake Country, Duluth and Lake Superior's North Shore, Metro Area, Southeast Minnesota and Bluff Country, and Minnesota Scenes. A visitor and native alike can appreciate this book containing photos from around the state. It is a good travel companion, as it includes narrative on the subjects, and it is a good travel-planning supplement, as some of the sites can't be found in any other travel book. It is also a good reminder of places already traveled and will stir excitement for places yet unseen.

Now go! Make these Minnesota Memories your own.

*M*innesota's Prairie Grasslands
pages 10-27

*L*ake Country
pages 28-52

*D*uluth and Lake Superior's North Shore
pages 53-72

*M*etro Area
pages 73-94

*S*outheastern Minnesota and Bluff Country
pages 95-107

*S*cenic Minnesota
pages 108-129

Minnesota Memos (Expanded Descriptions) .130-161

Locations Referenced in Captions (State Map) .162

Minnesota State Parks and Cities Index .163-165

"I've Been There" Checklist .166-168

MINNESOTA'S PRAIRIE GRASSLANDS

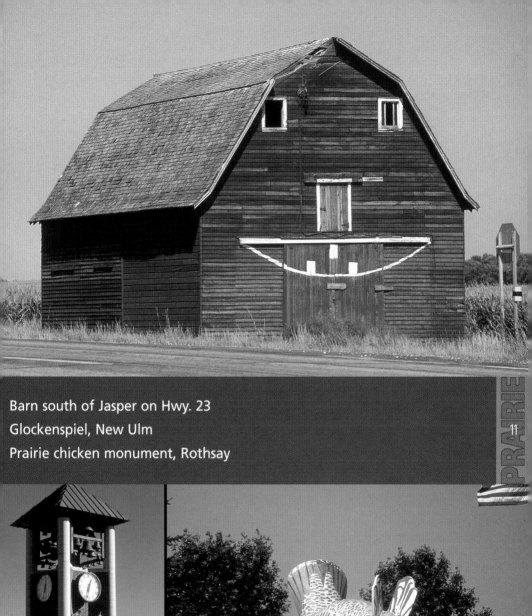

Barn south of Jasper on Hwy. 23

Glockenspiel, New Ulm

Prairie chicken monument, Rothsay

PRAIRIE

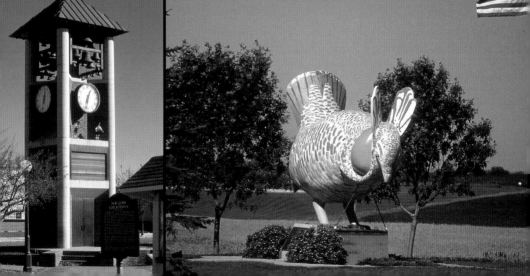

Springtime in west central Minnesota

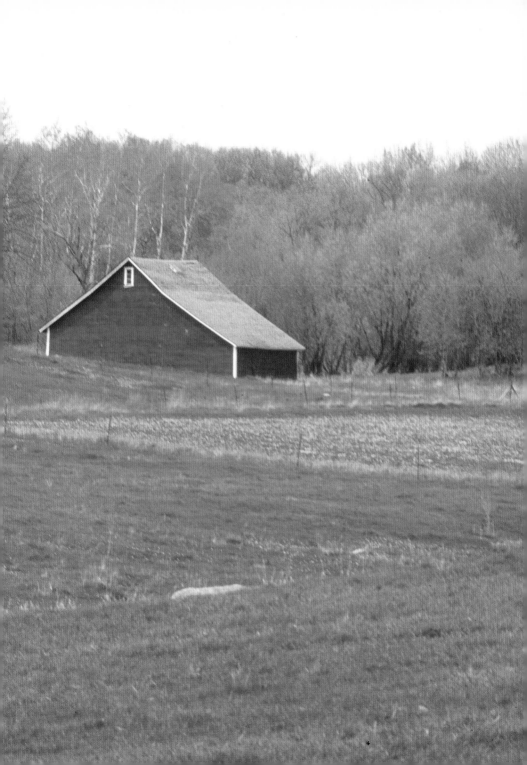

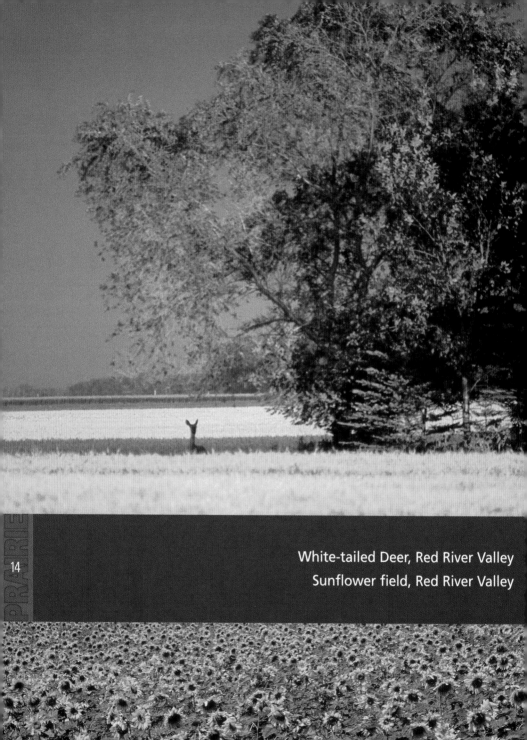

White-tailed Deer, Red River Valley
Sunflower field, Red River Valley

Minnesota River Valley, north of New Ulm
Harvest time in south central Minnesota
Harvest time in south central Minnesota

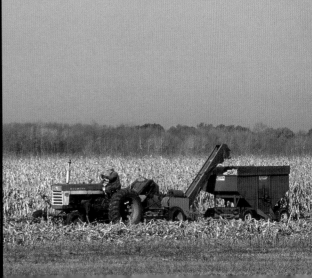

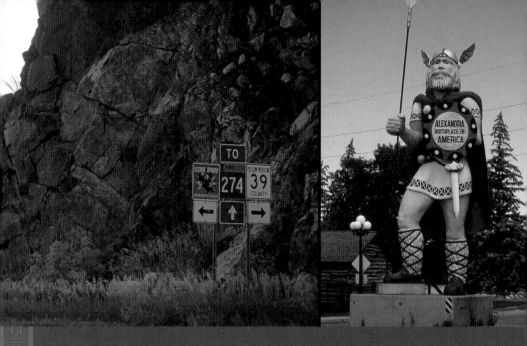

Granite Falls
Big Ole, Alexandria
Old Mill State Park, near Argyle

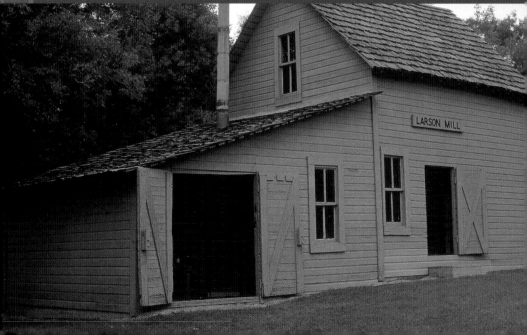

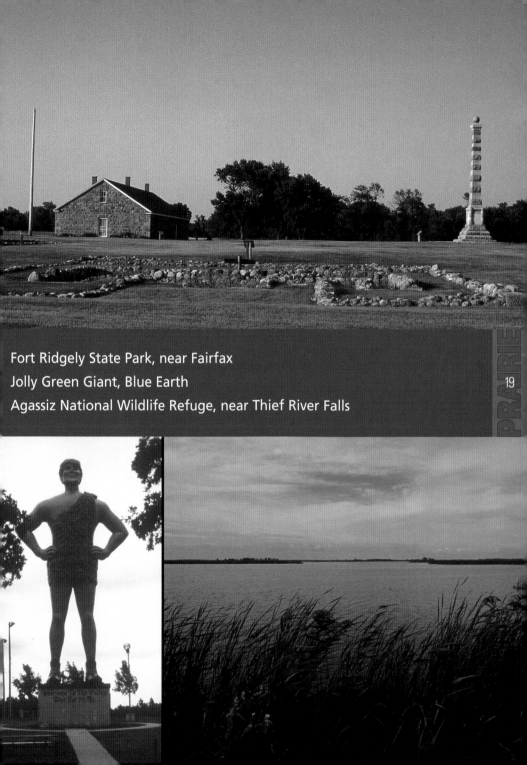

Fort Ridgely State Park, near Fairfax

Jolly Green Giant, Blue Earth

Agassiz National Wildlife Refuge, near Thief River Falls

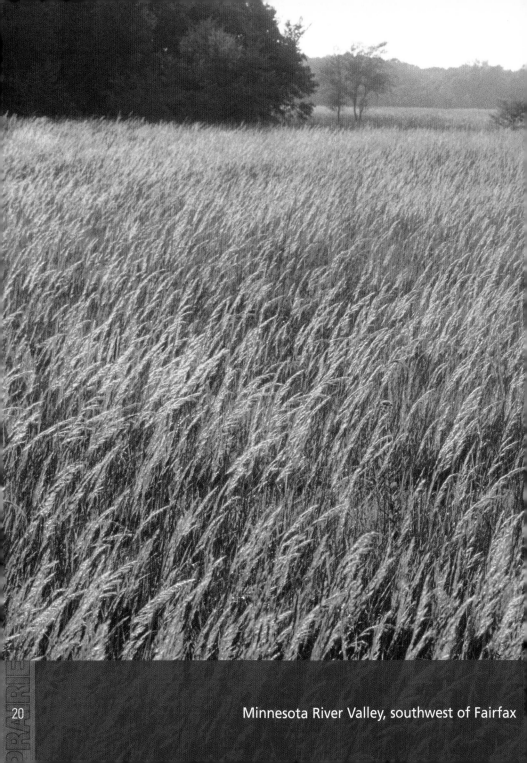

Minnesota River Valley, southwest of Fairfax

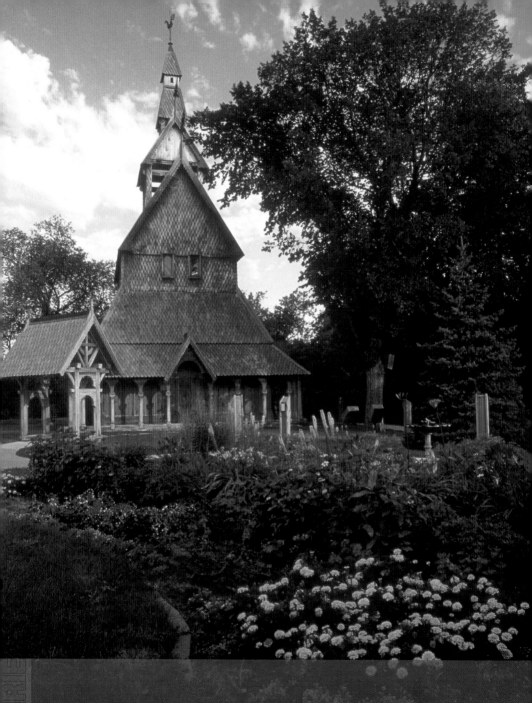

Stavkirke, Moorhead

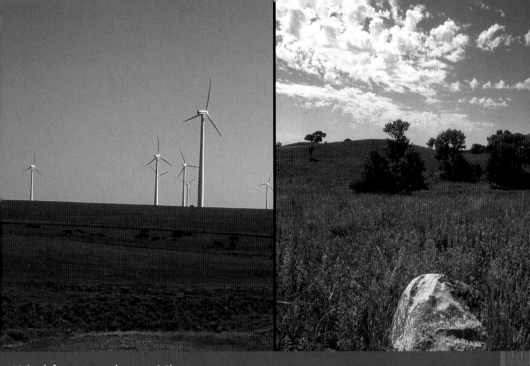

Wind farm, southwest Minnesota
Glacial Lake State Park, near Starbuck
River Otter statue, Fergus Falls
Glacial Lake State Park, near Starbuck

PRAIRIE

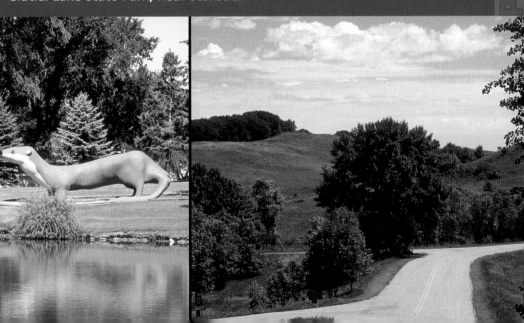

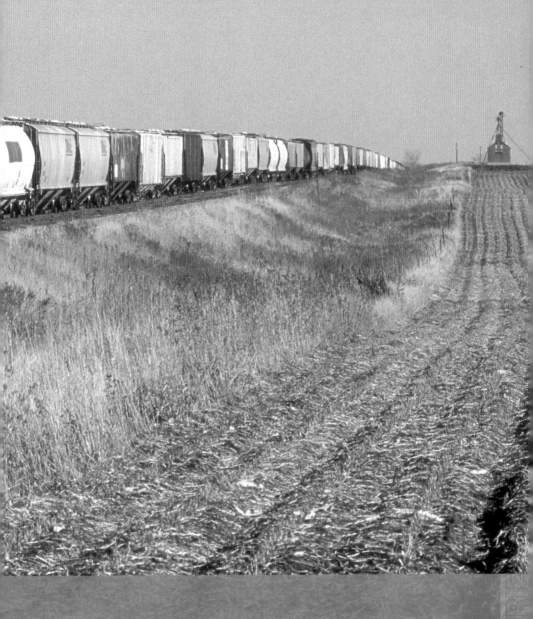

Harvest time in southeast Minnesota

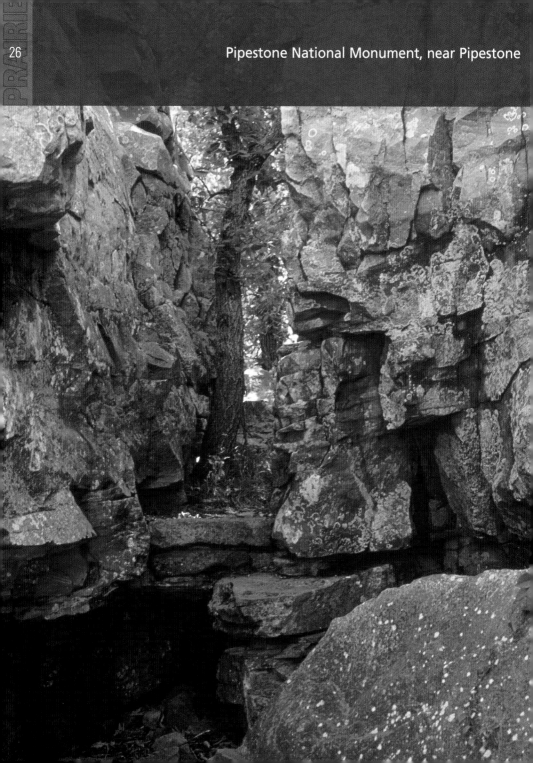

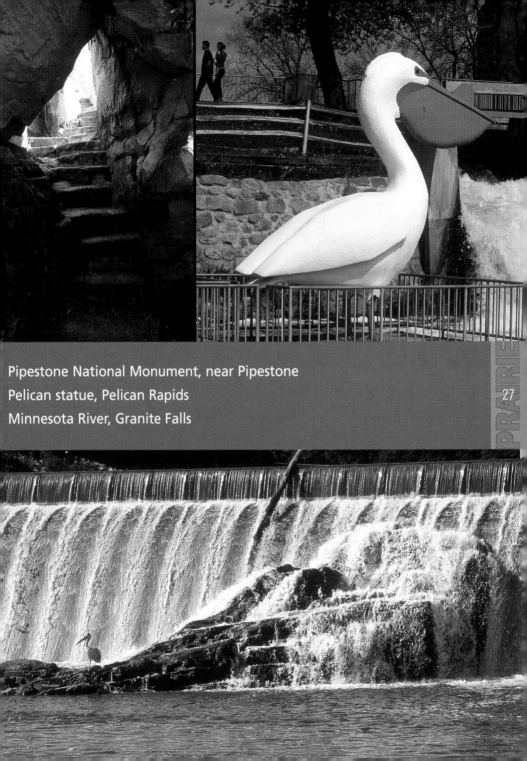

Pipestone National Monument, near Pipestone
Pelican statue, Pelican Rapids
Minnesota River, Granite Falls

LAKE COUNTRY

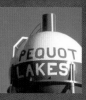

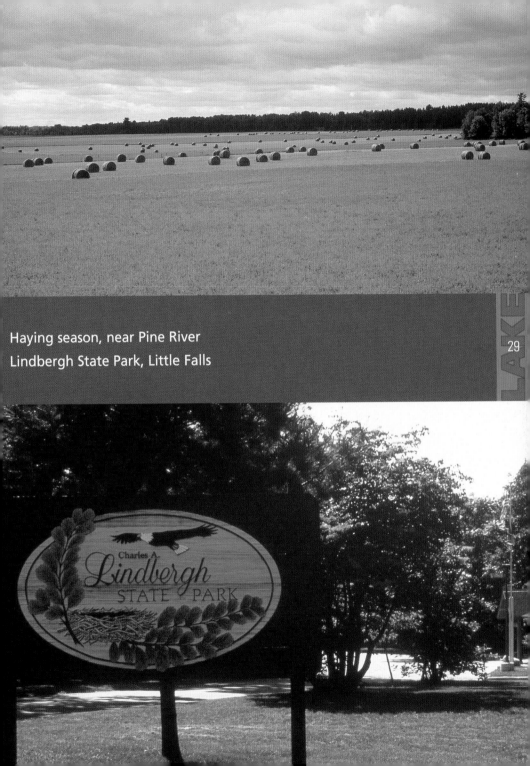

Haying season, near Pine River

Lindbergh State Park, Little Falls

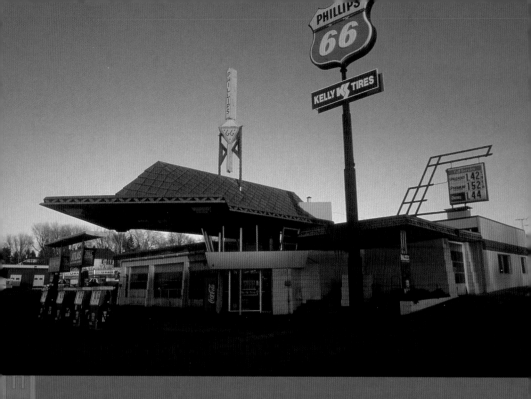

Lindholm Oil Company Service Station, designed by Frank Lloyd Wright, Cloquet

Jacob V. Brower Visitor Center, Itasca State Park, north of Park Rapids

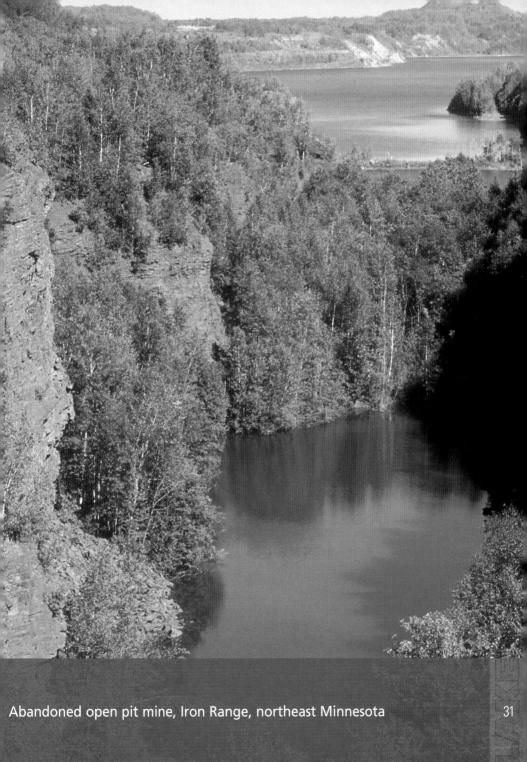

Abandoned open pit mine, Iron Range, northeast Minnesota

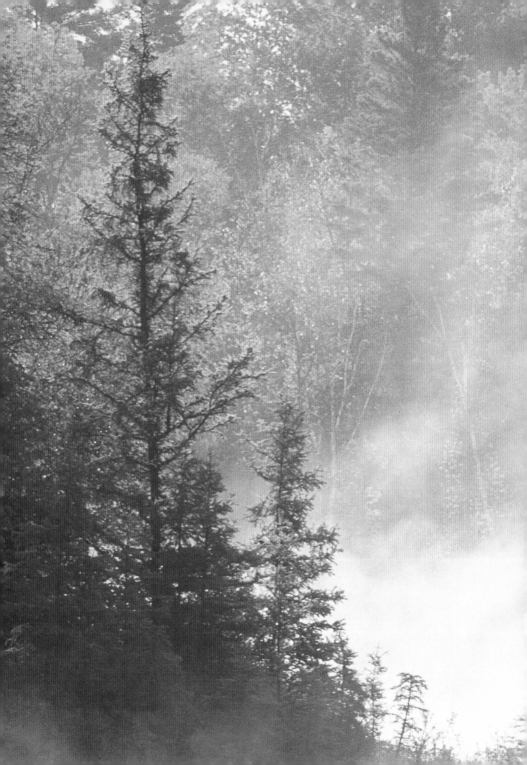

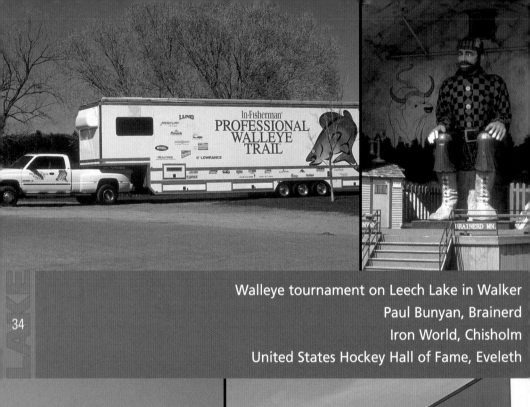

Walleye tournament on Leech Lake in Walker
Paul Bunyan, Brainerd
Iron World, Chisholm
United States Hockey Hall of Fame, Eveleth

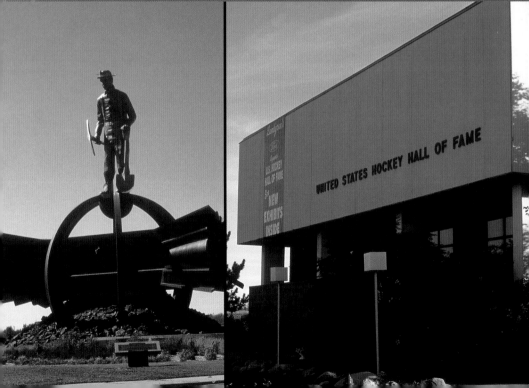

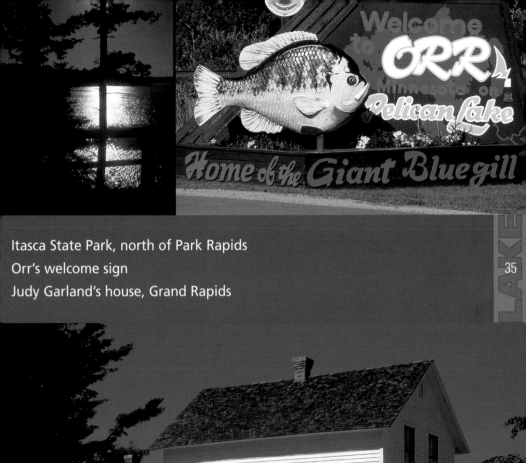

Itasca State Park, north of Park Rapids
Orr's welcome sign
Judy Garland's house, Grand Rapids

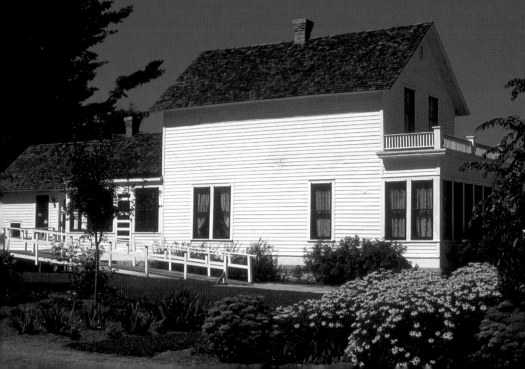

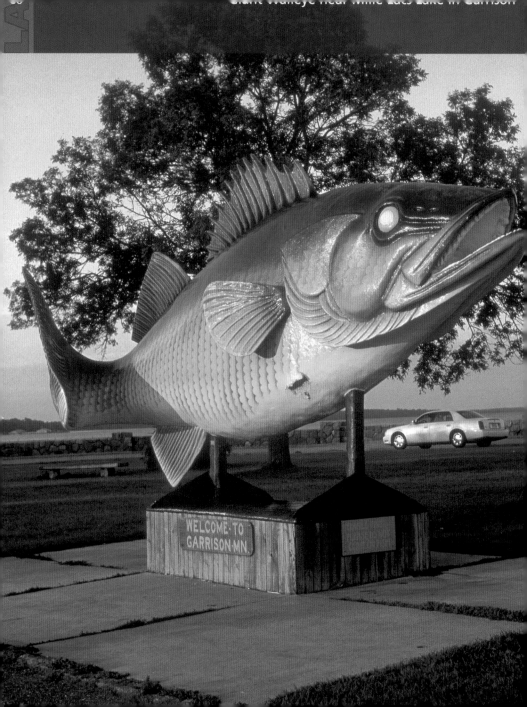

WELCOME TO
GARRISON MN.

Charles Lindbergh's boyhood home, Little Falls
Voyagaire Lodge on Crane Lake
Voyageurs National Park

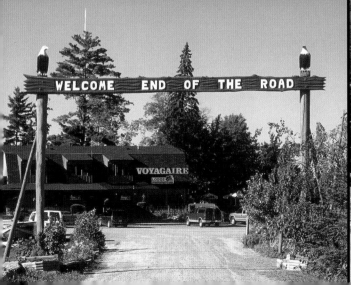

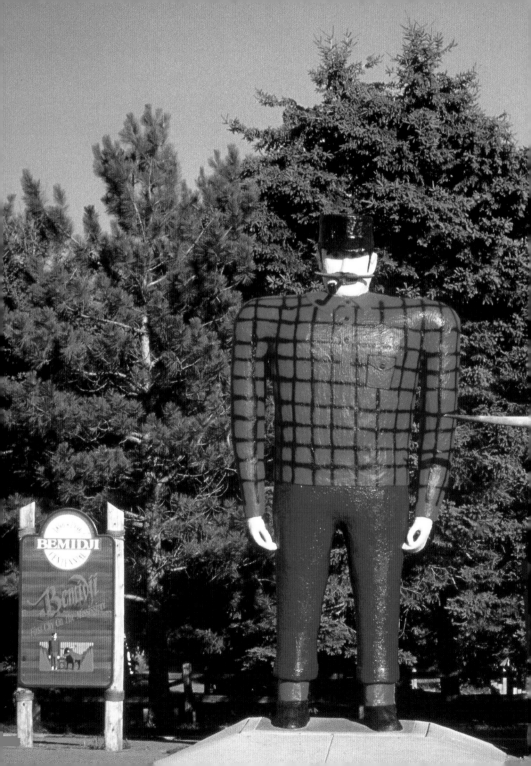

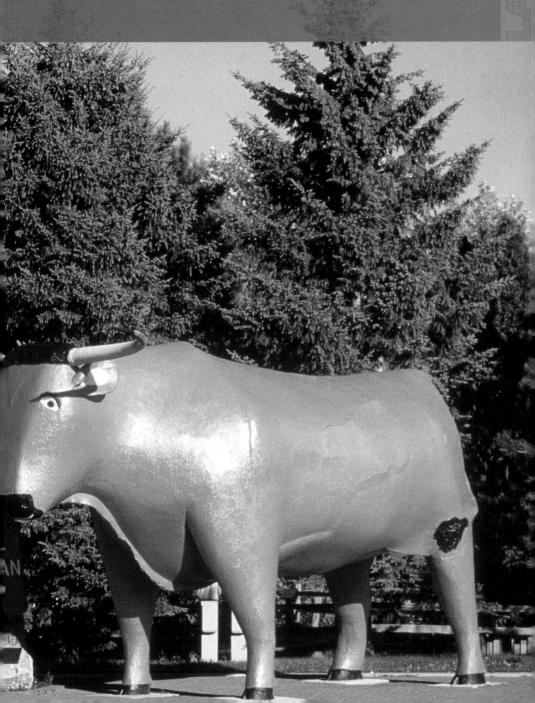

LAKE

40

Headwaters of the Mississippi River, Itasca State Park, north of Park Rapids
The Red Bridge, Park Rapids
Logging in northern Minnesota

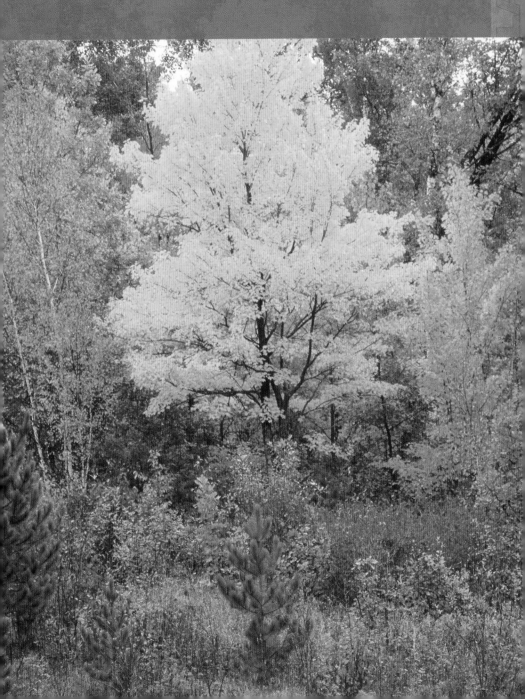

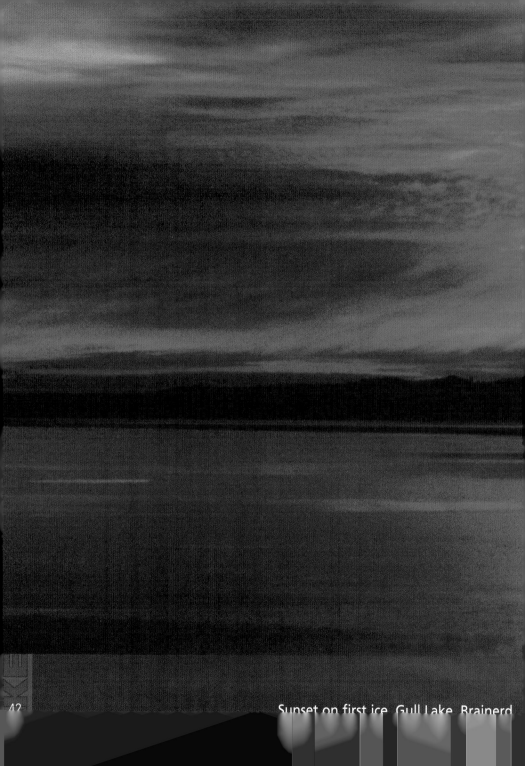

Sunset on first ice, Gull Lake, Brainerd

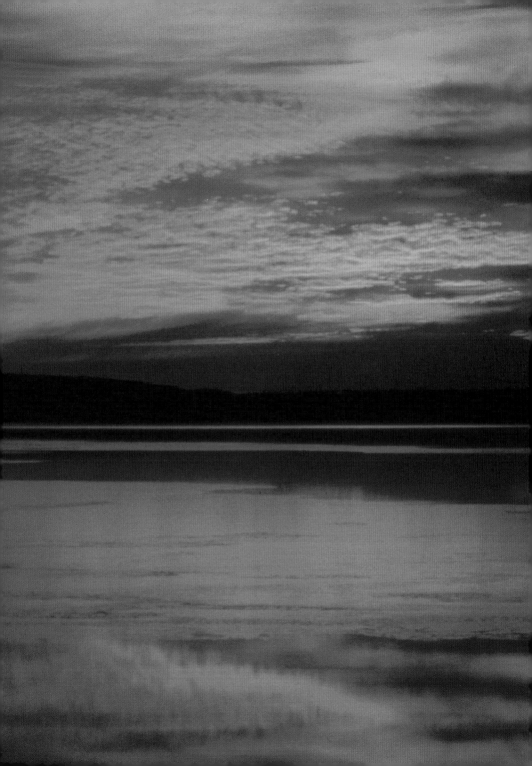

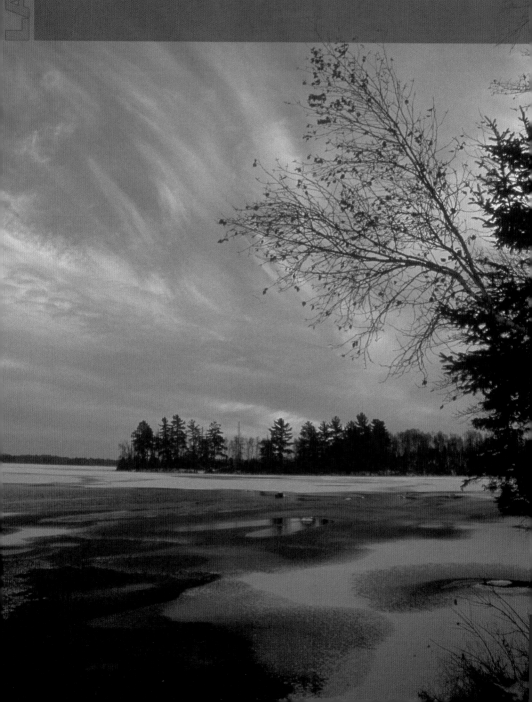

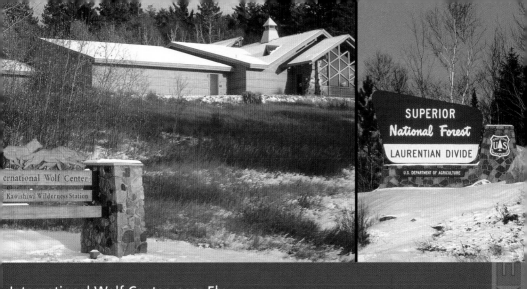

International Wolf Center, near Ely

Entrance to the Superior National Forest, Laurentian Divide, near Virginia

Back roads of northern Minnesota

LAKE

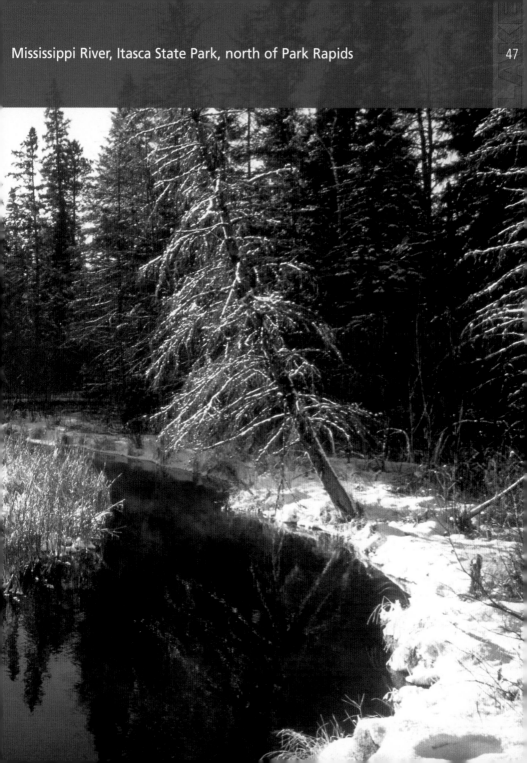

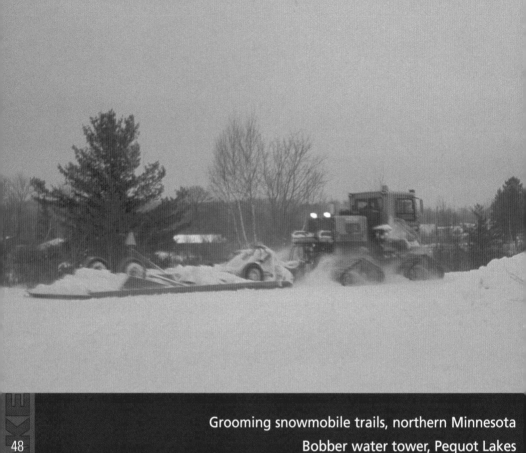

Grooming snowmobile trails, northern Minnesota
Bobber water tower, Pequot Lakes
Babe the Blue Ox, Brainerd

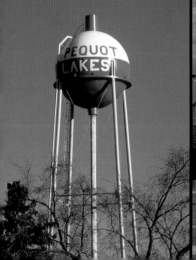

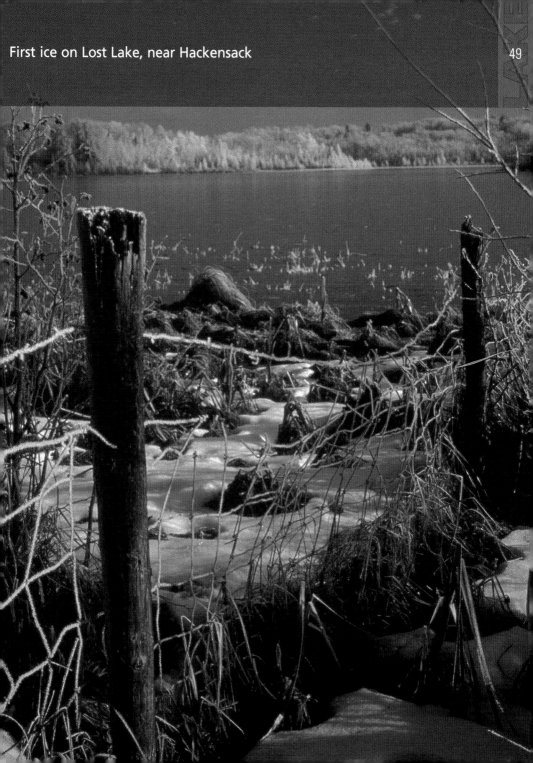

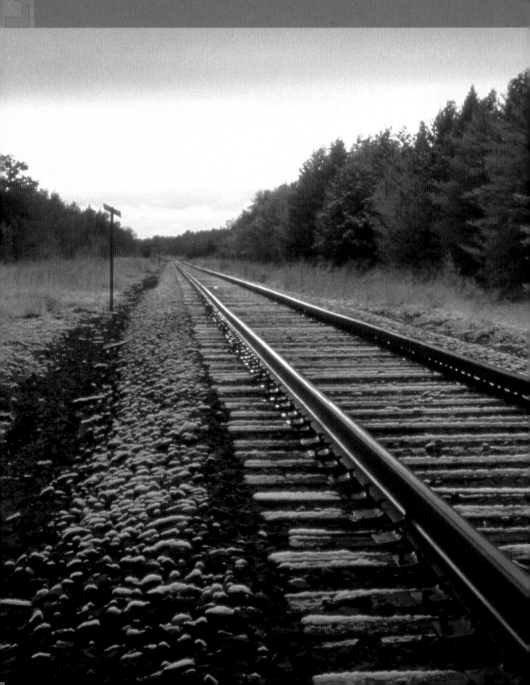

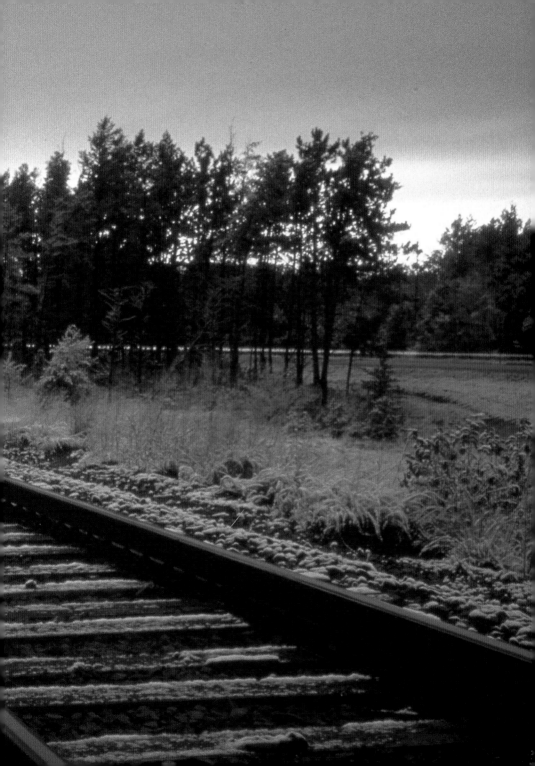

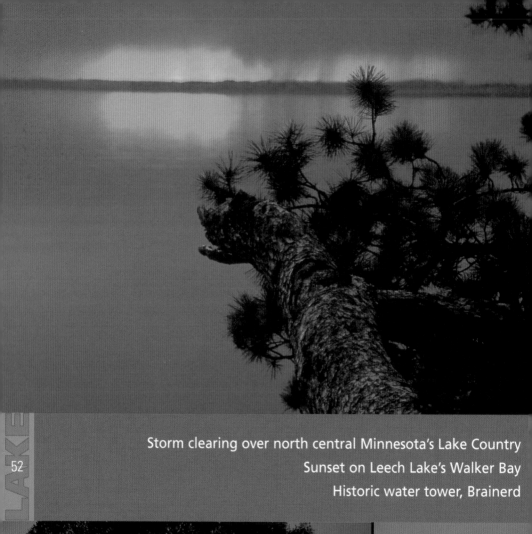

Storm clearing over north central Minnesota's Lake Country
Sunset on Leech Lake's Walker Bay
Historic water tower, Brainerd

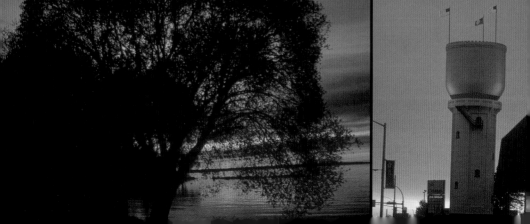

DULUTH AND LAKE SUPERIOR'S NORTH SHORE

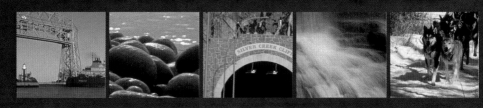

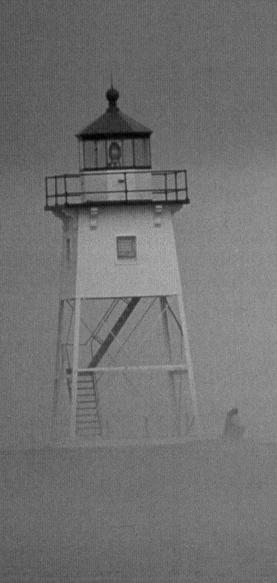

Lighthouse, Grand Marais

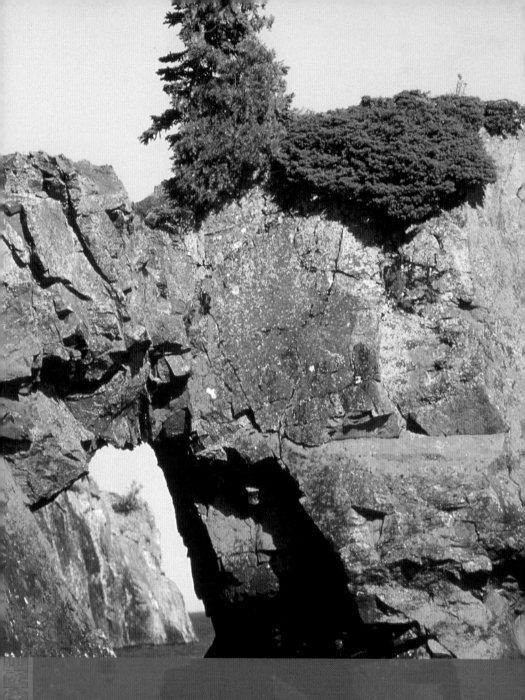

Lake Superior's North Shore

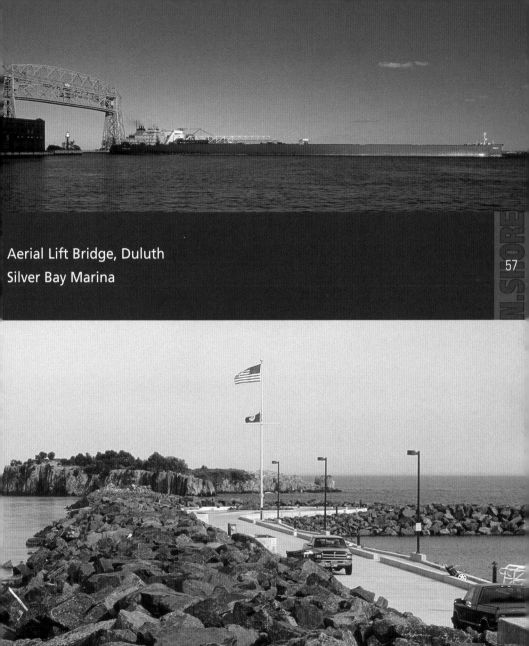

Aerial Lift Bridge, Duluth

Silver Bay Marina

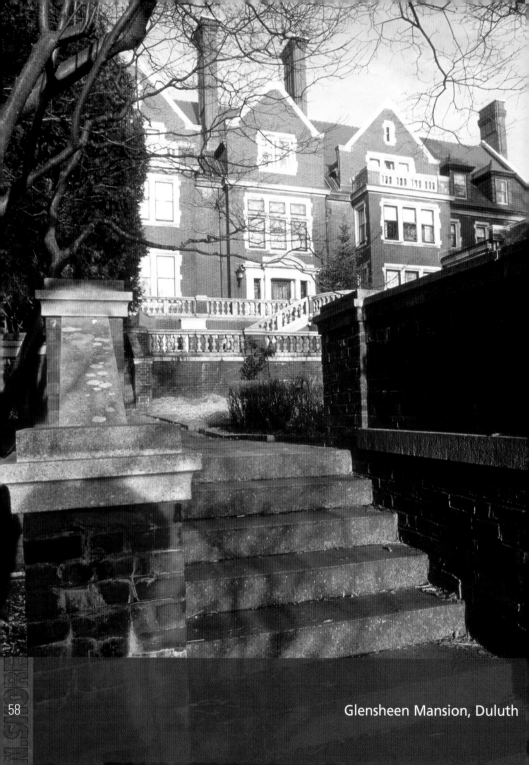

Glensheen Mansion, Duluth

NLShore

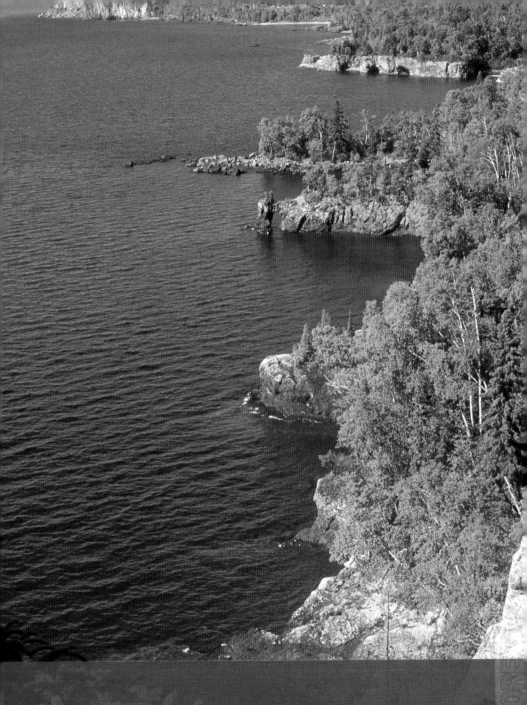

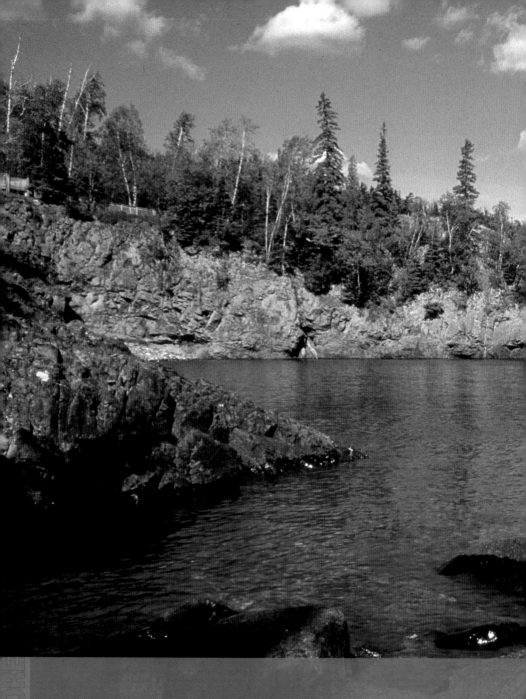

Shovel Point, Tettegouche State Park, near Silver Bay

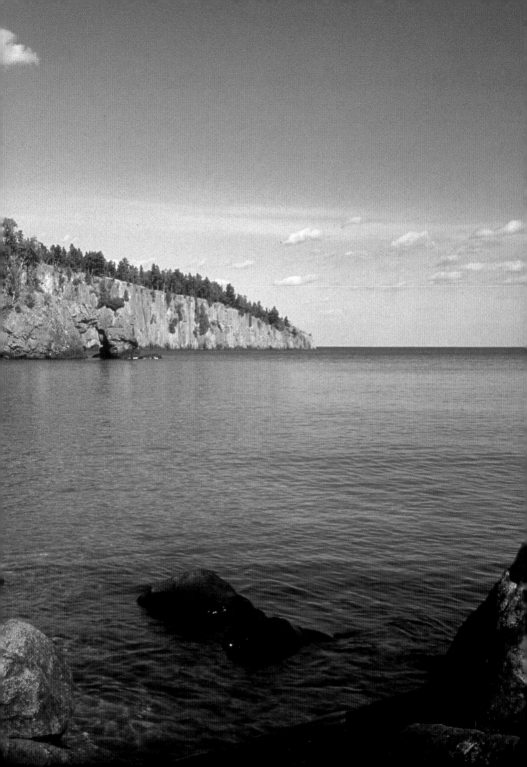

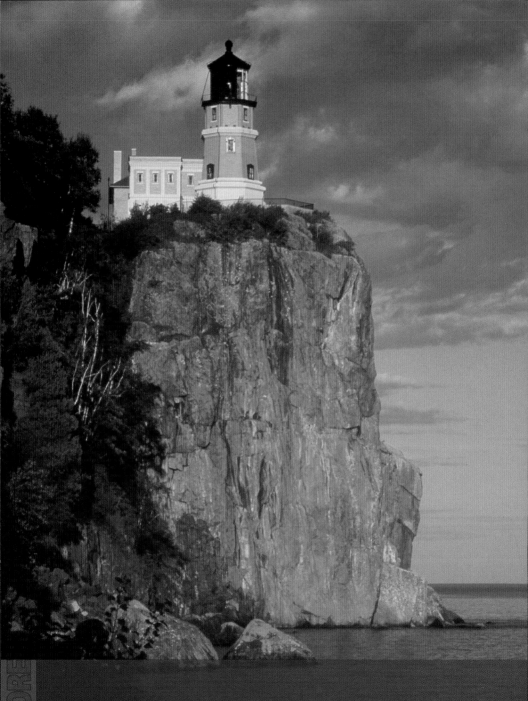

Split Rock Lighthouse State Park, near Two Harbors

Rose Garden in Leif Erikson Park, Duluth
Hawk Ridge Nature Reserve, Duluth
Great Lakes Aquarium, Duluth
Silver Creek Tunnel on Hwy. 61, near Two Harbors

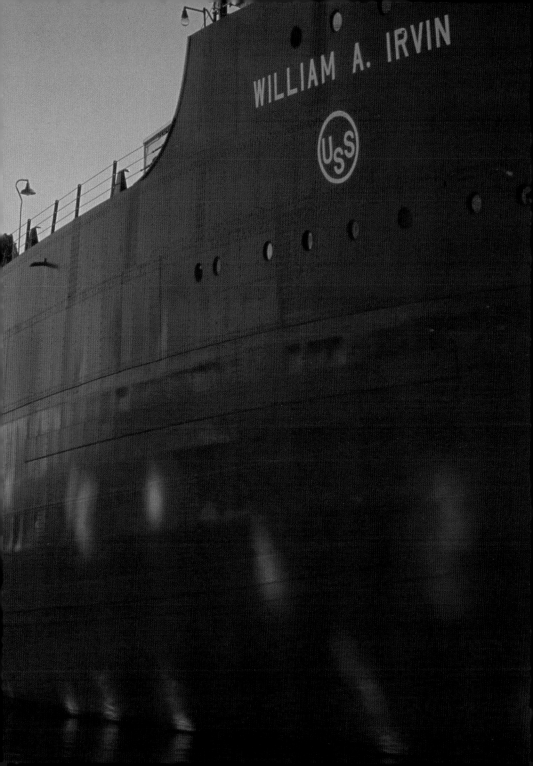

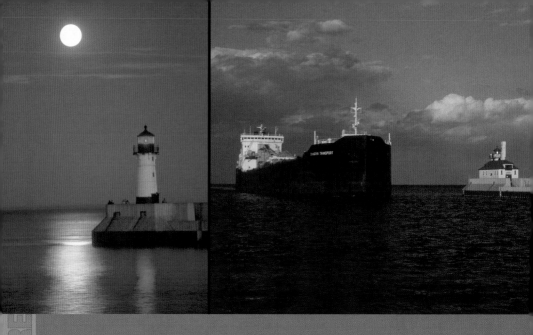

Canal Park Lighthouse, Duluth
Duluth's harbor
Lower Falls, Gooseberry Falls State Park, near Two Harbors

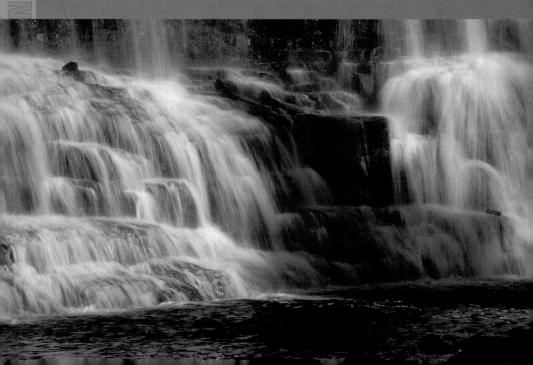

Sunrise over Lake Superior in Grand Marais
Gateway to the Gunflint Trail, Grand Marais
Upper Falls, Gooseberry Falls State Park, near Two Harbors

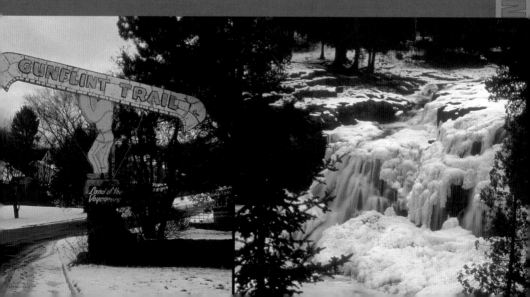

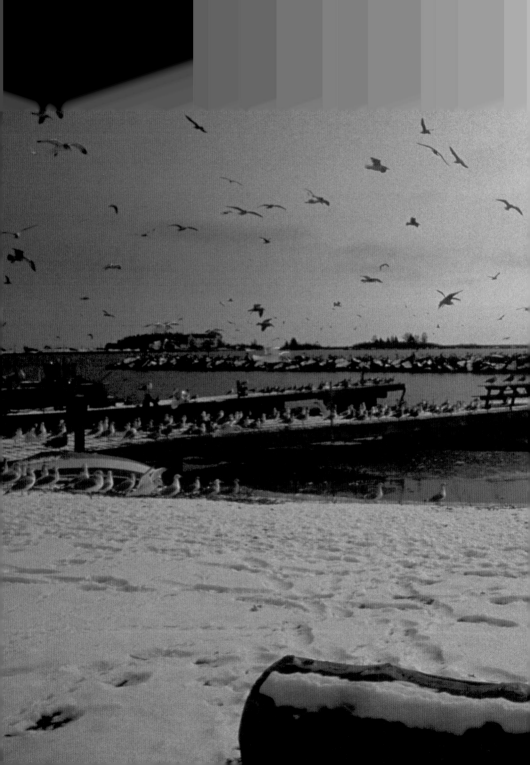

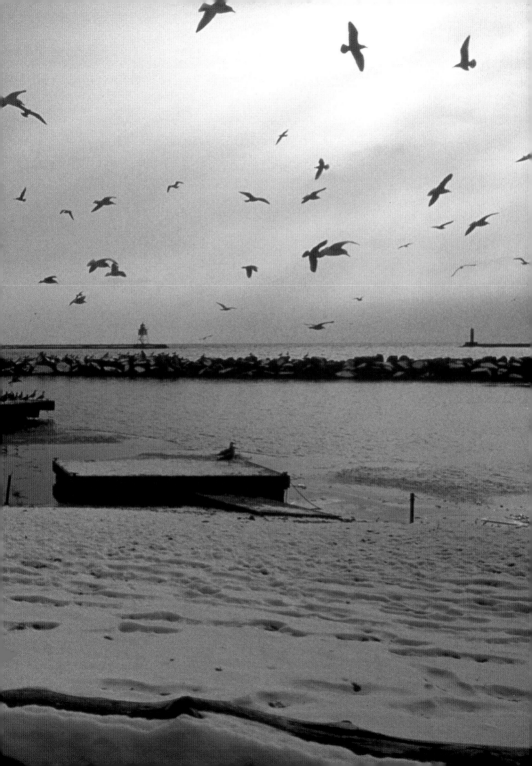

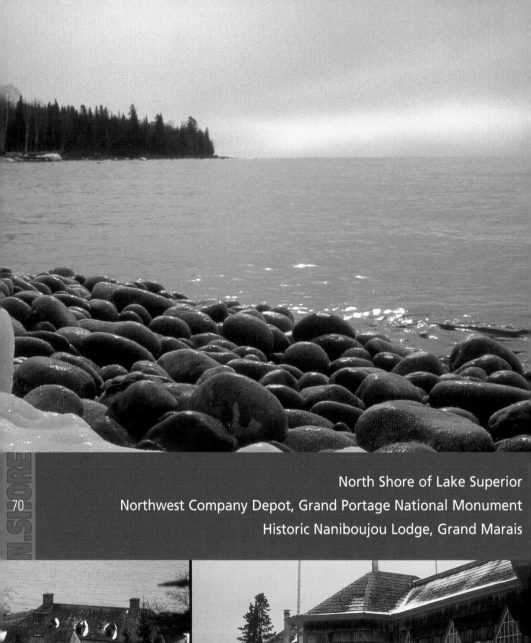

N.SHORE

North Shore of Lake Superior
Northwest Company Depot, Grand Portage National Monument
Historic Naniboujou Lodge, Grand Marais

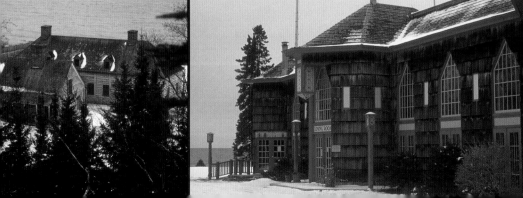

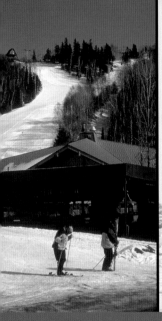

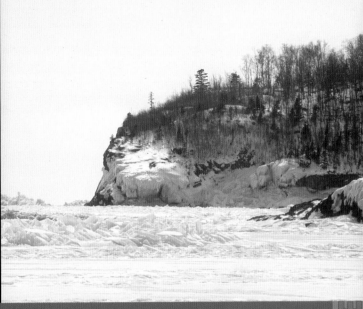

Lutsen Ski Resort

Winter on the North Shore of Lake Superior

Lighthouse at Two Harbors

John Beargrease Sled Dog Marathon along Minnesota's North Shore

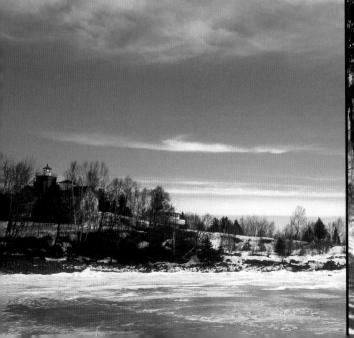

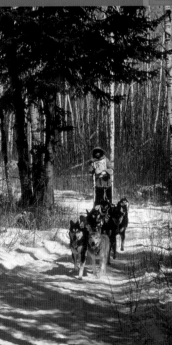

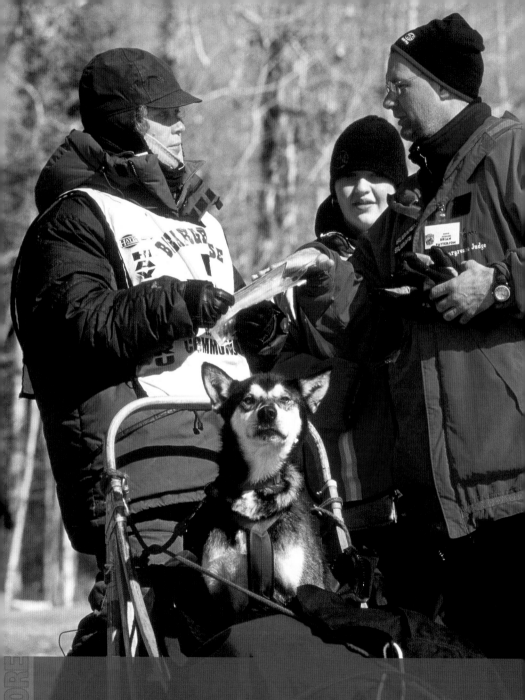

John Beargrease Sled Dog Marathon, Finland Checkpoint

METRO AREA

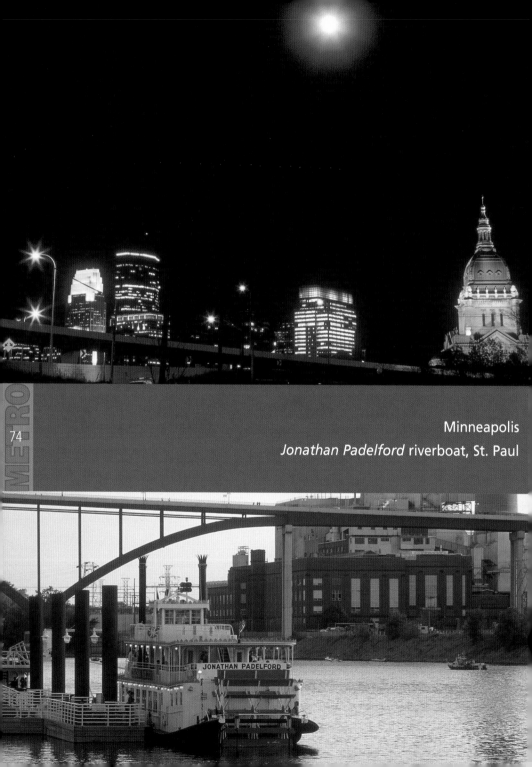

METRO

Minneapolis
Jonathan Padelford riverboat, St. Paul

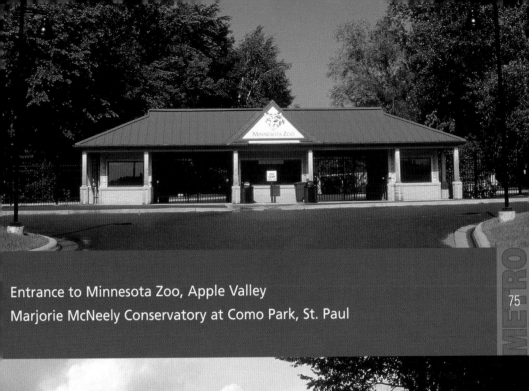

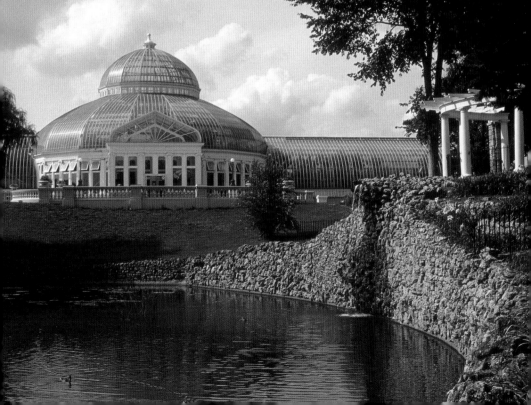

Entrance to Minnesota Zoo, Apple Valley
Marjorie McNeely Conservatory at Como Park, St. Paul

METRO

The Minneapolis Institute of Arts
Minneapolis-St. Paul International Airport
Mall of America, Bloomington

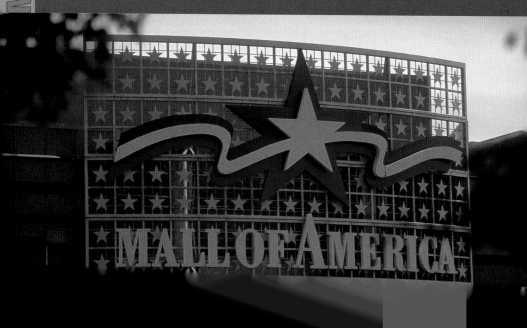

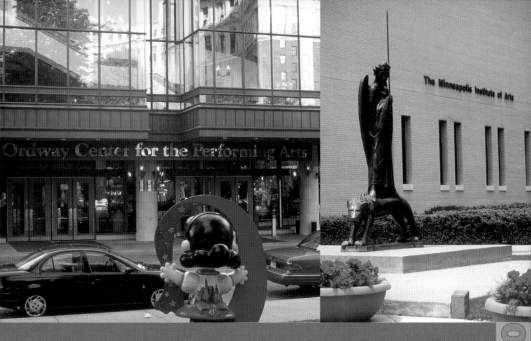

Ordway Center for the Performing Arts, St. Paul
The Minneapolis Institute of Arts
Minnesota's capitol, St. Paul

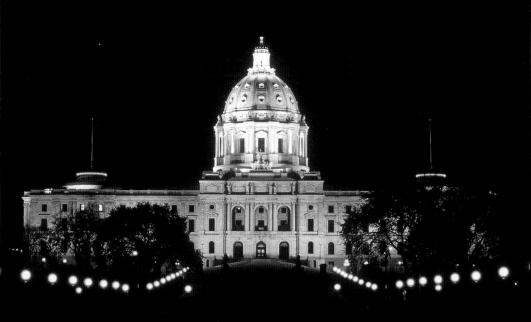

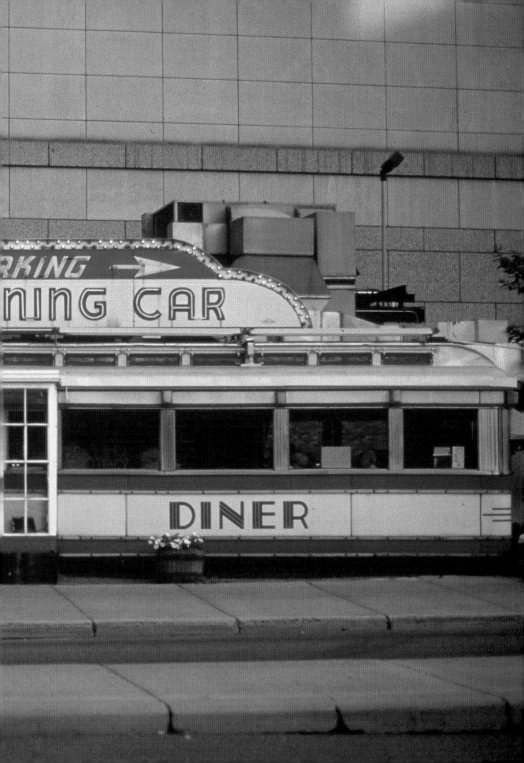

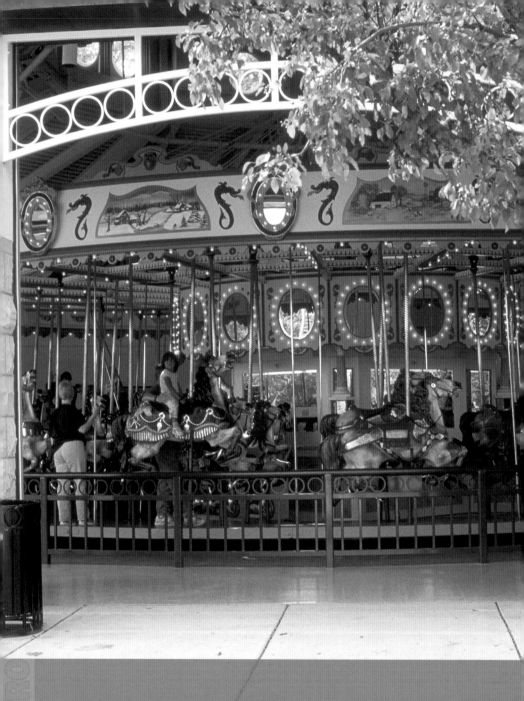

Cafesjian's Carousel, Como Park, St. Paul

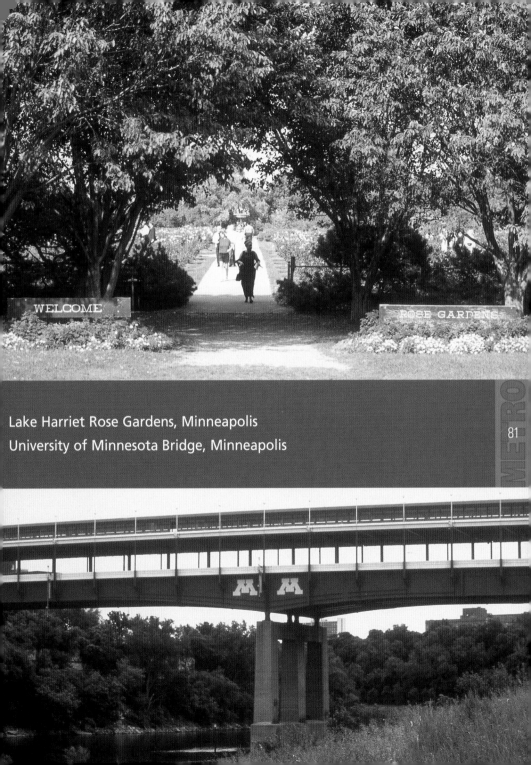

Lake Harriet Rose Gardens, Minneapolis
University of Minnesota Bridge, Minneapolis

METRO

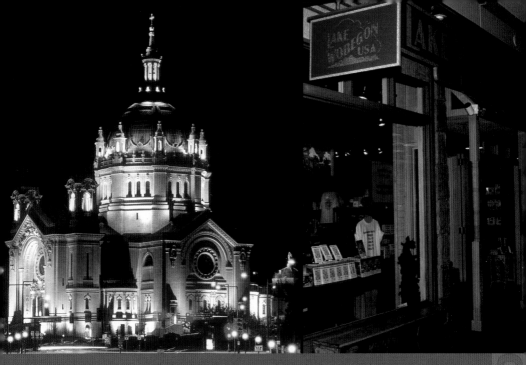

Cathedral of St. Paul
Lake Wobegon Store, Mall of America, Bloomington
The Minneapolis Institute of Arts
Minnesota's capitol, St. Paul

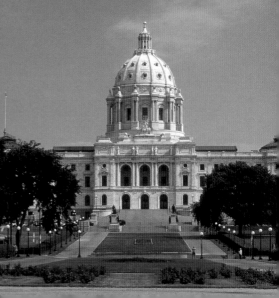

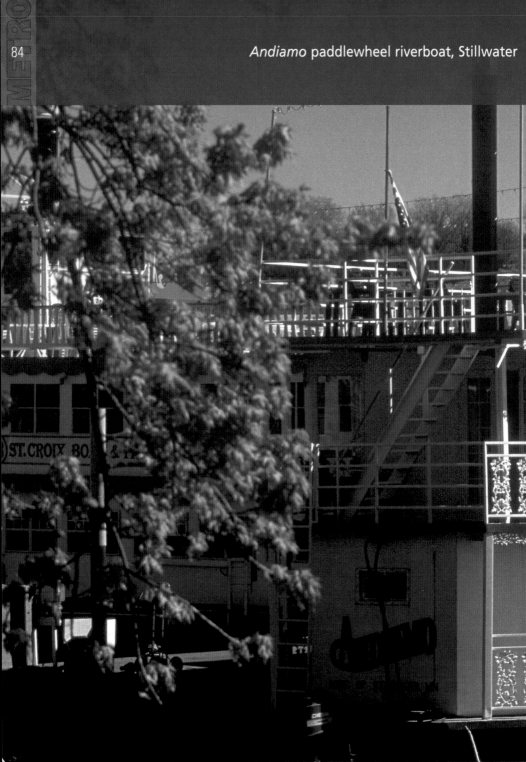

METRO

Andiamo paddlewheel riverboat, Stillwater

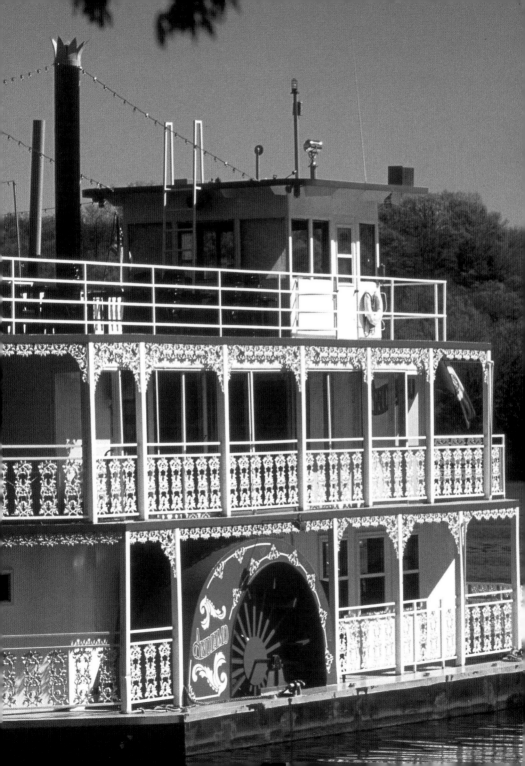

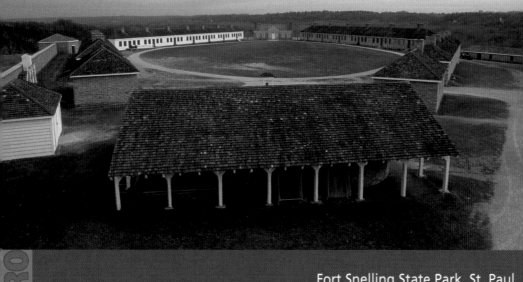

Fort Snelling State Park, St. Paul
Minnehaha Falls, Minneapolis
Cathedral of St. Paul

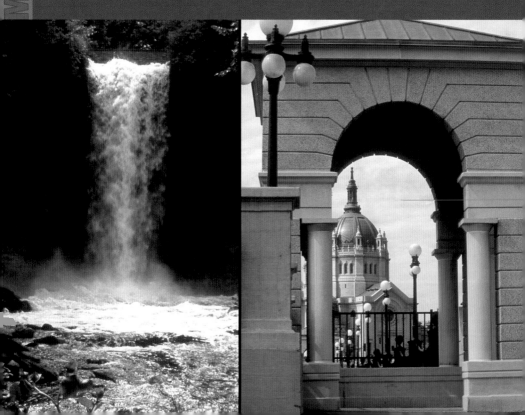

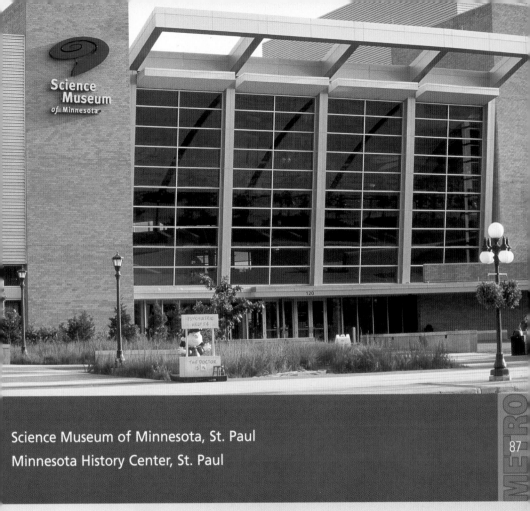

Science Museum of Minnesota, St. Paul

Minnesota History Center, St. Paul

METRO

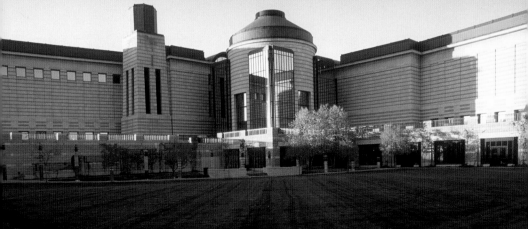

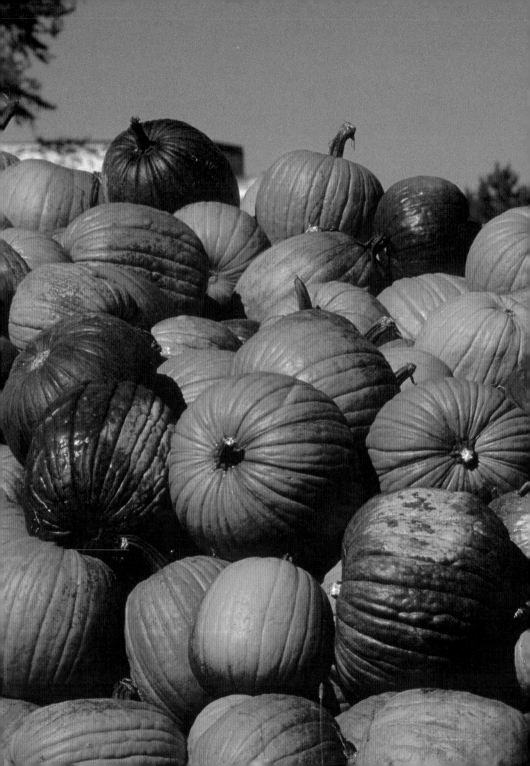

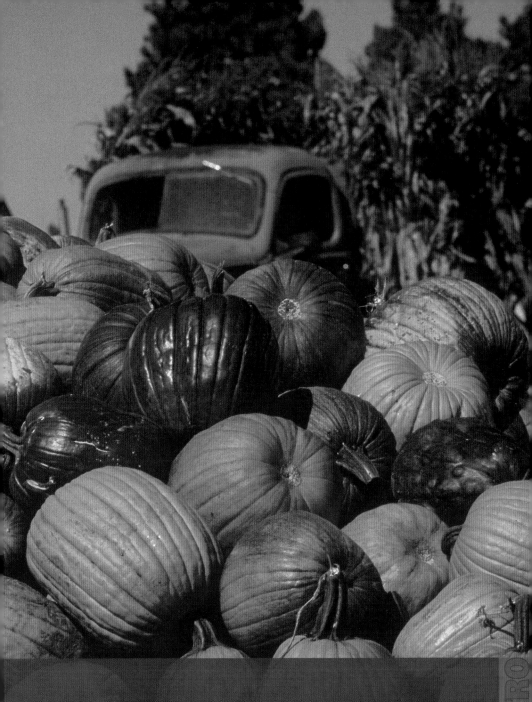

Pumpkins, Belle Plaine

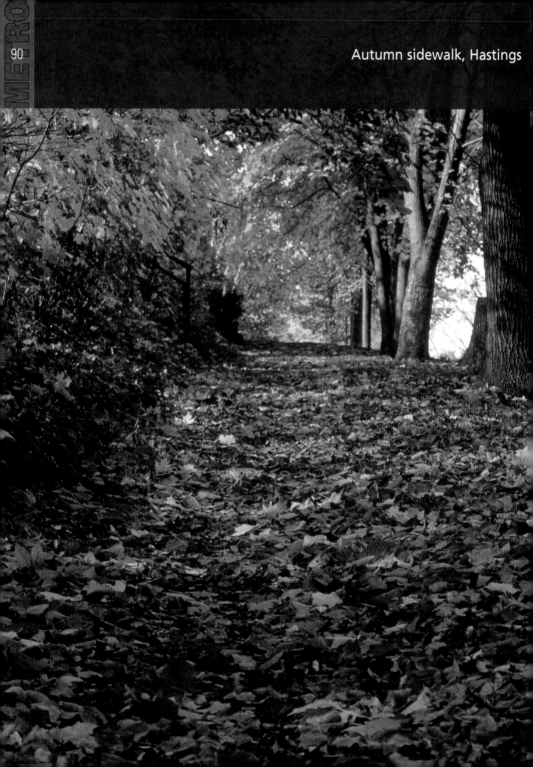

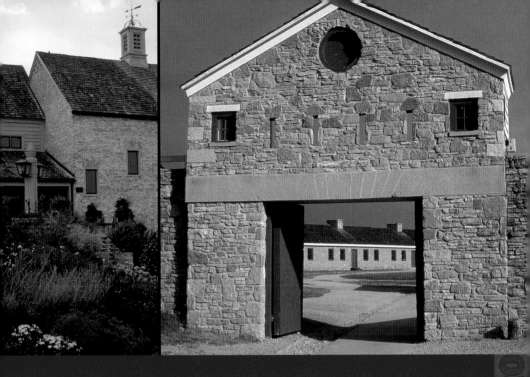

The Minnesota Landscape Arboretum, Chanhassen
Main gate, Fort Snelling State Park, St. Paul
Longfellow House, Minneapolis

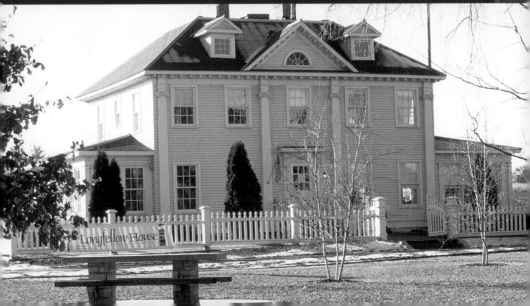

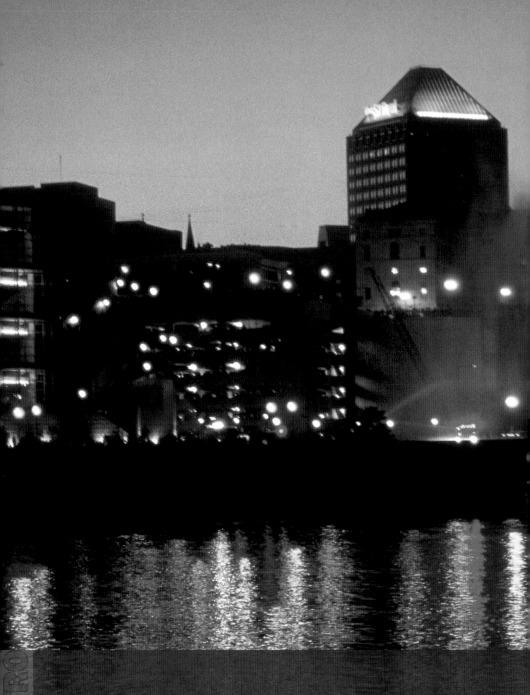

St. Paul from Harriet Island

METRO

Holidazzle Parade, Minneapolis

SOUTHEASTERN MINNESOTA AND BLUFF COUNTRY

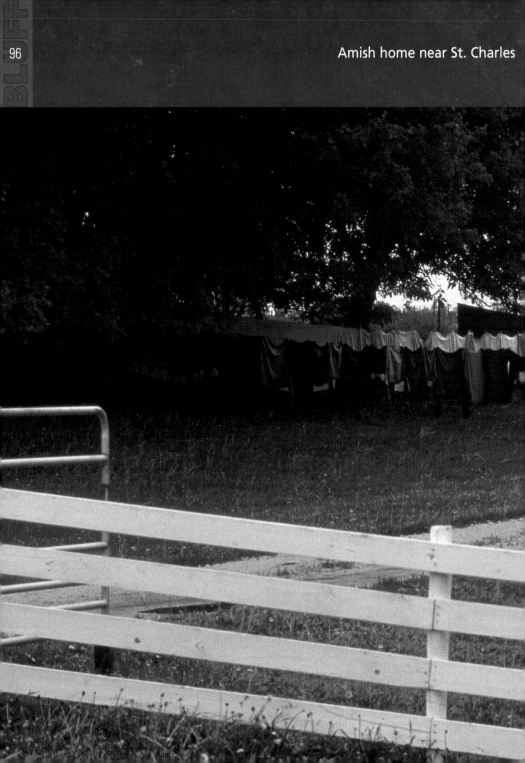

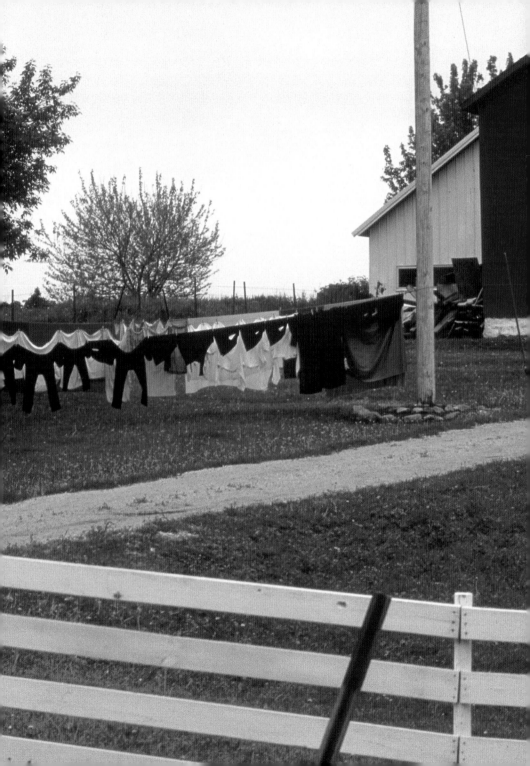

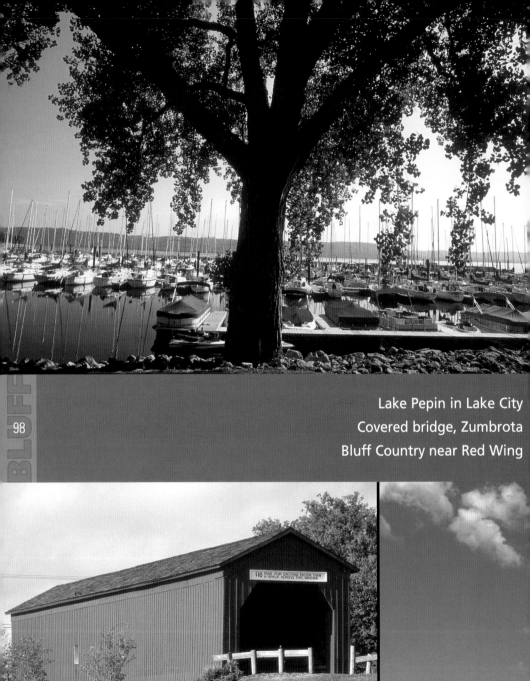

BLUFF

Lake Pepin in Lake City
Covered bridge, Zumbrota
Bluff Country near Red Wing

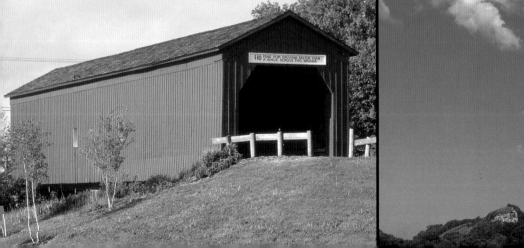

$10 FINE FOR DRIVING FASTER THAN A WALK ACROSS THIS BRIDGE

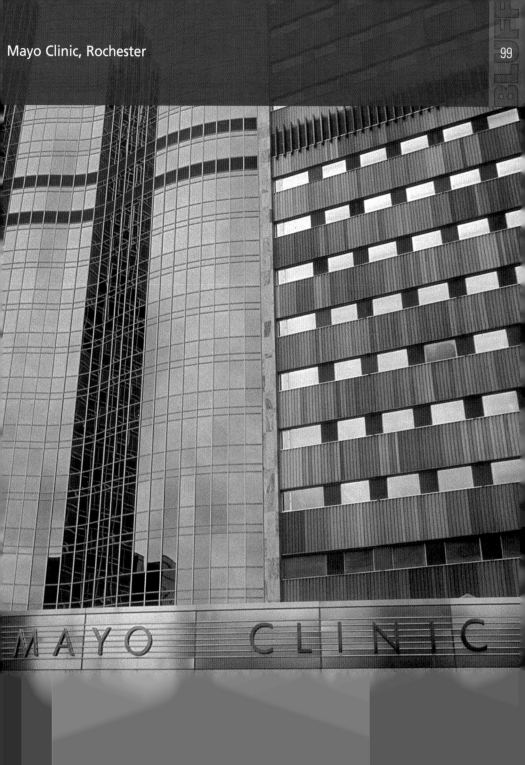

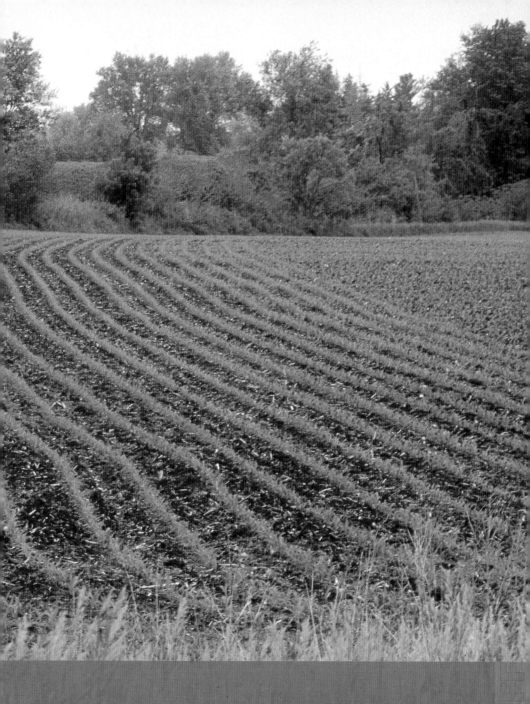

Springtime fields, southeastern Minnesota

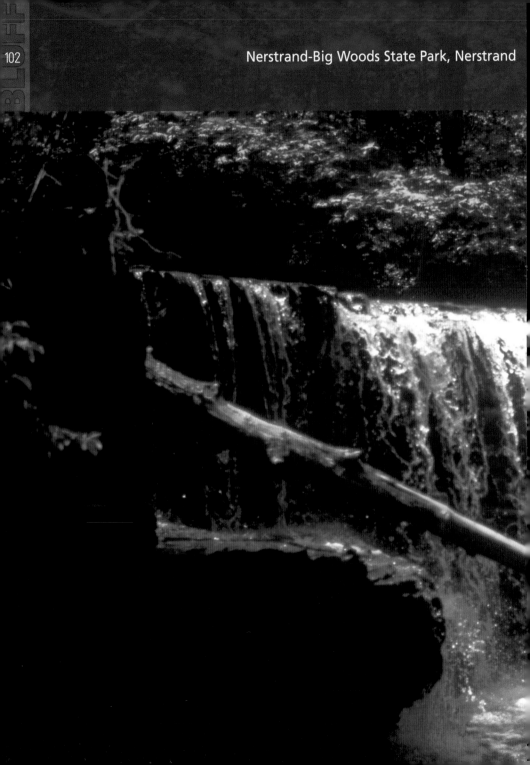

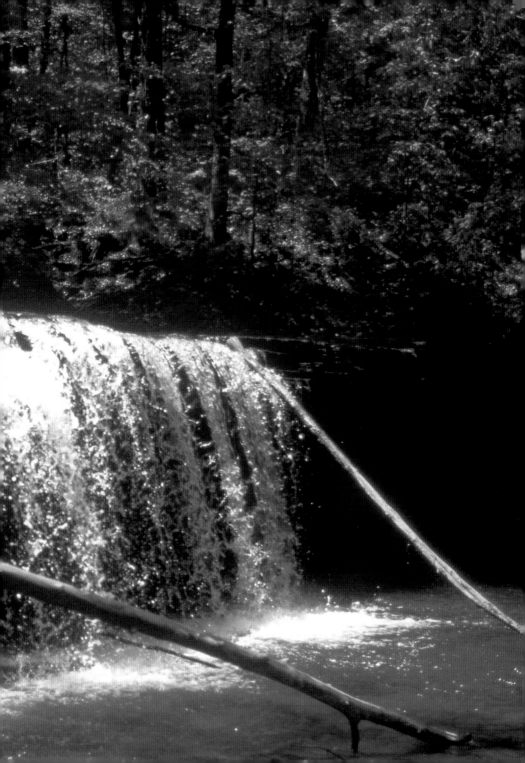

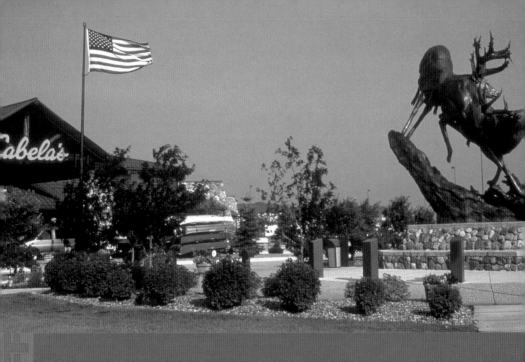

Cabela's, Owatonna
Bluff Country near Winona

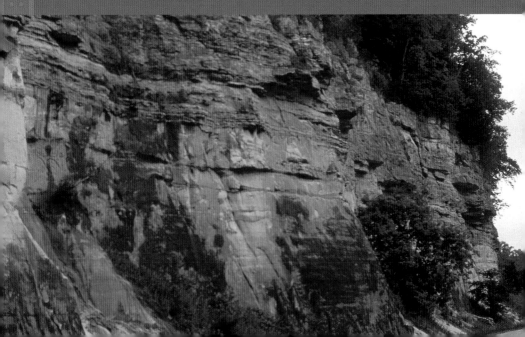

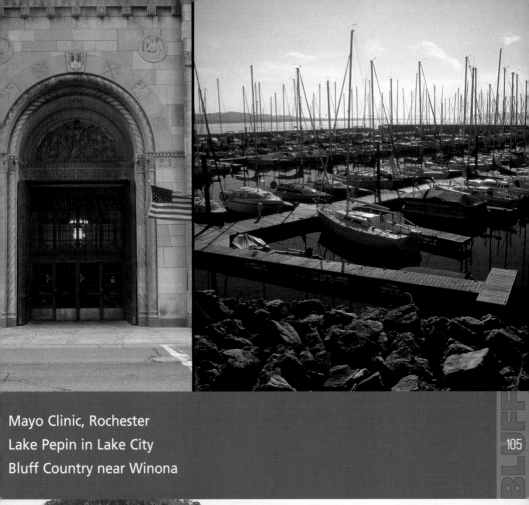

Mayo Clinic, Rochester
Lake Pepin in Lake City
Bluff Country near Winona

BLUFF

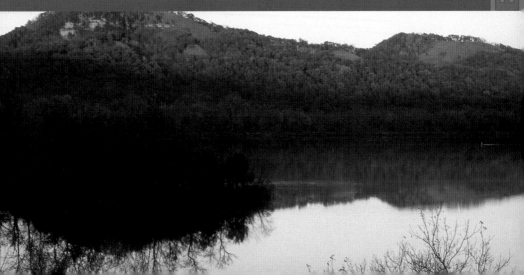

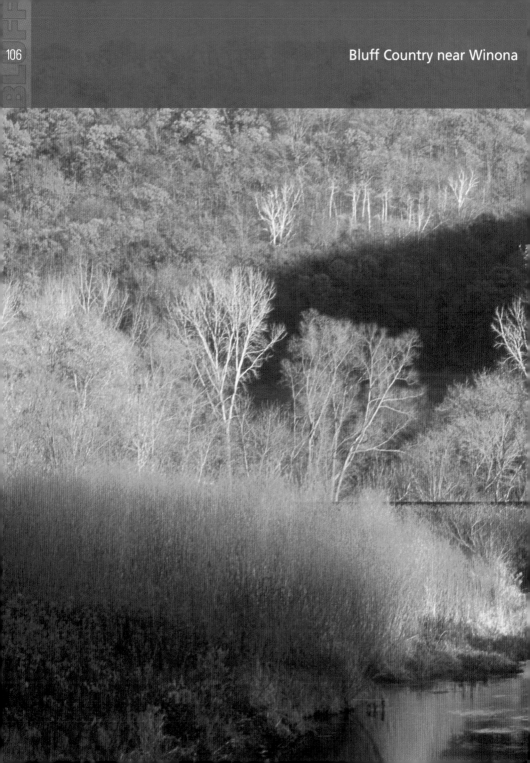

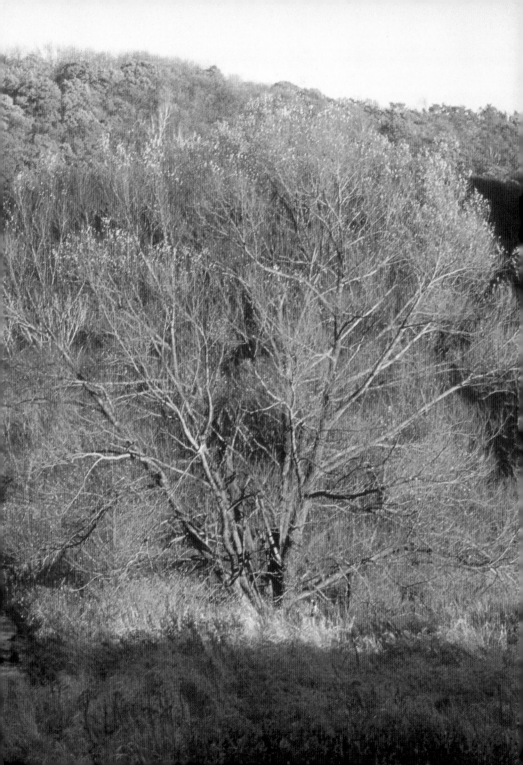

SCENIC
MINNESOTA

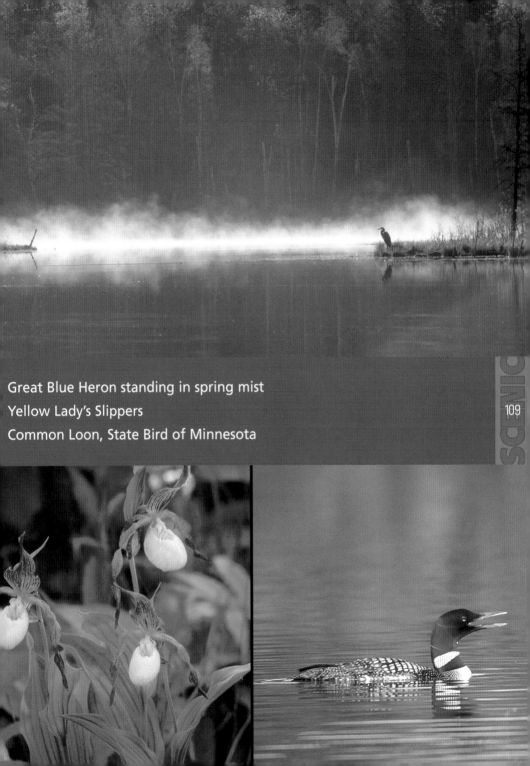

Great Blue Heron standing in spring mist
Yellow Lady's Slippers
Common Loon, State Bird of Minnesota

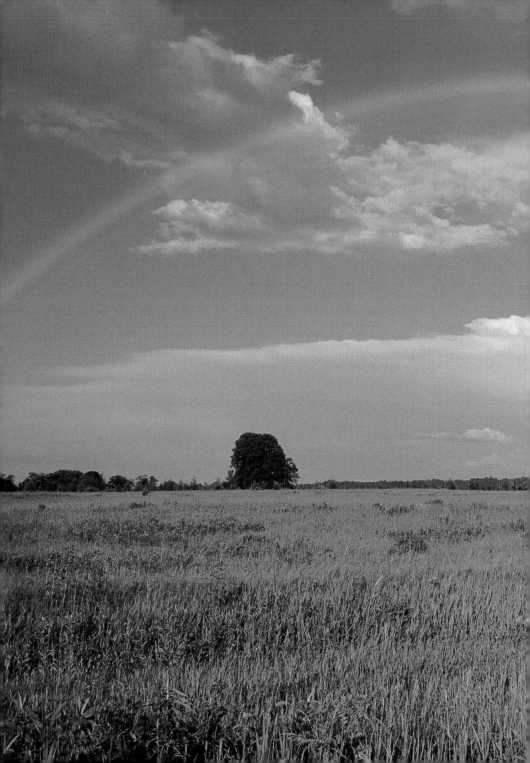

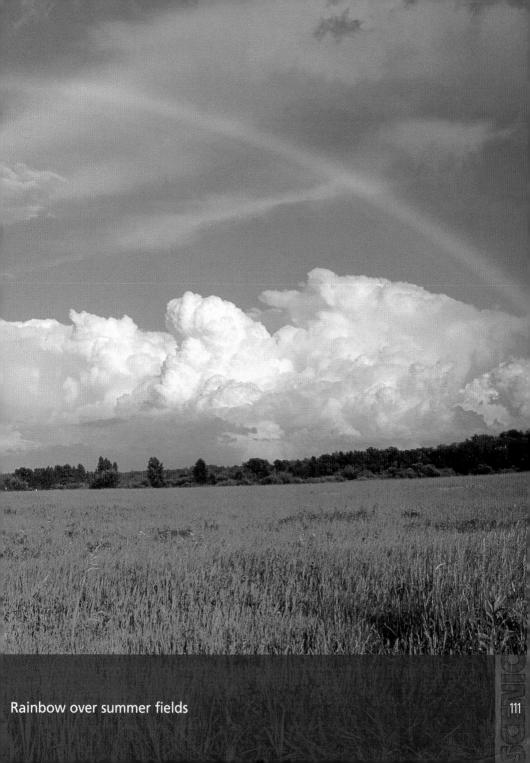

Rainbow over summer fields

SCENIC

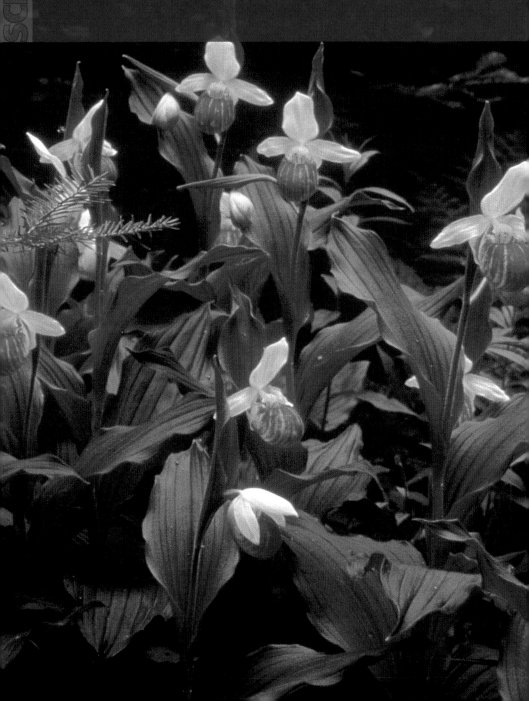

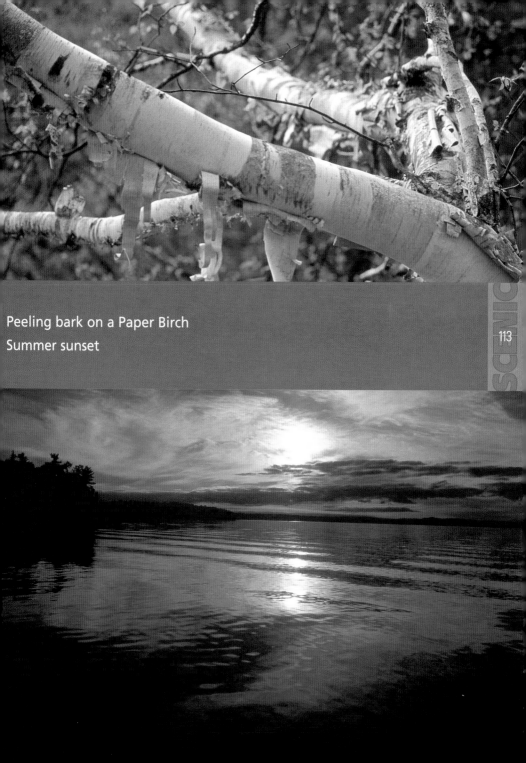

Peeling bark on a Paper Birch
Summer sunset

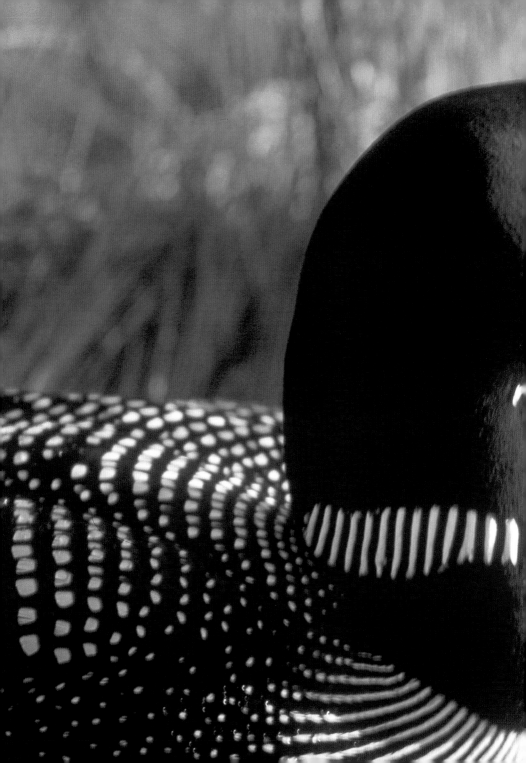

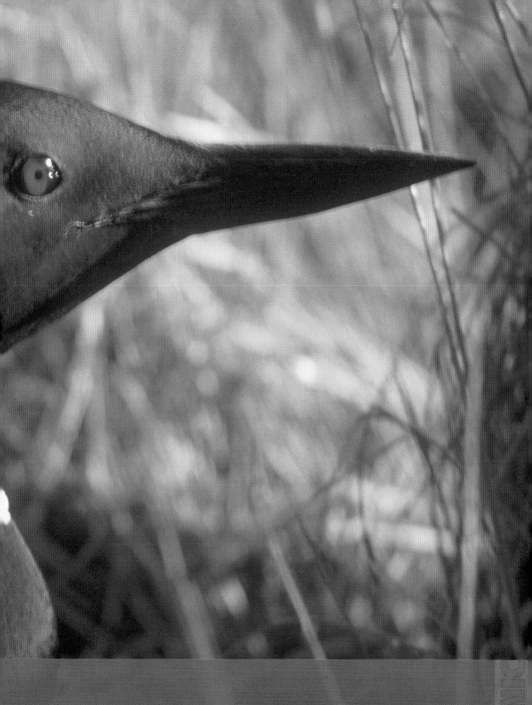

Common Loon, State Bird of Minnesota

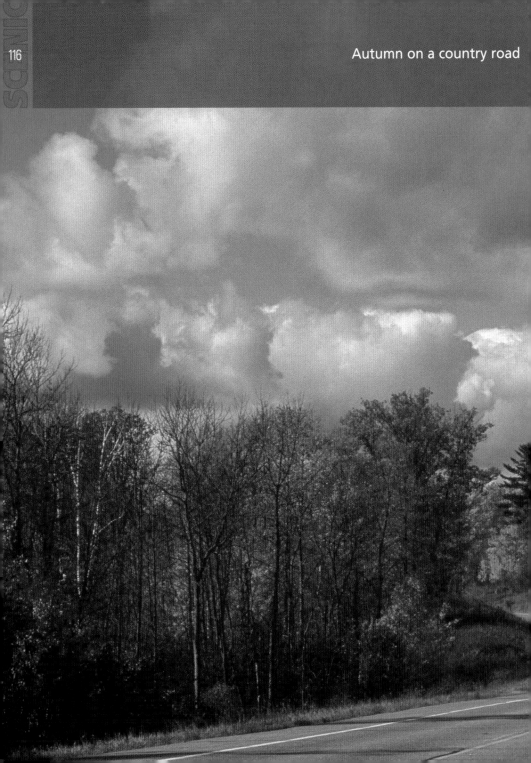

Autumn on a country road

SCENIC

Autumn maple
Sportsman's collection
Autumn on Leech Lake

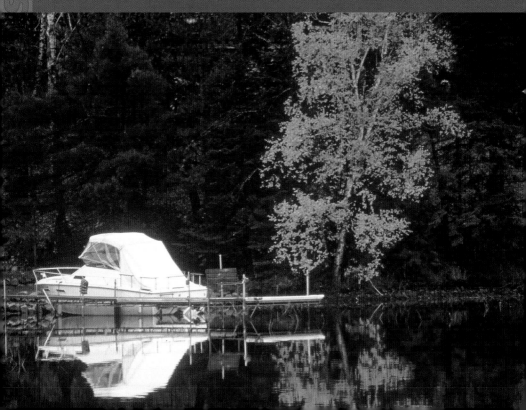

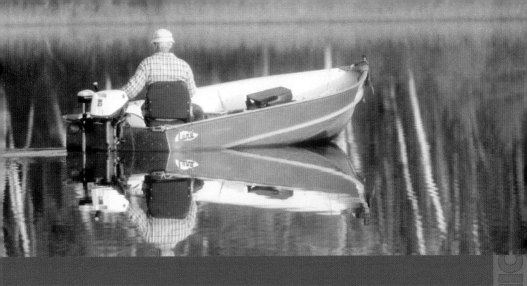

Autumn fishing trip
Autumn on Leech Lake

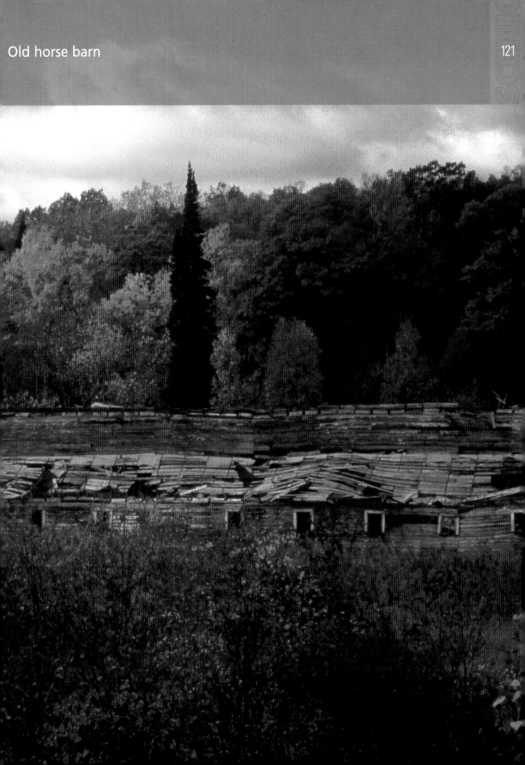

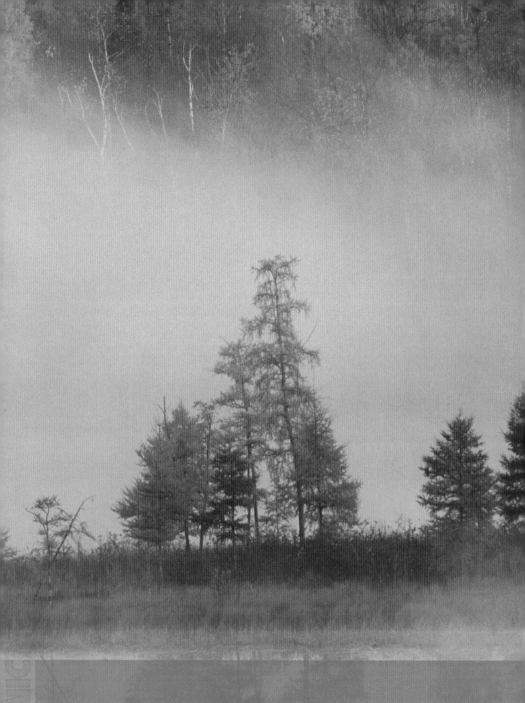

Autumn morning

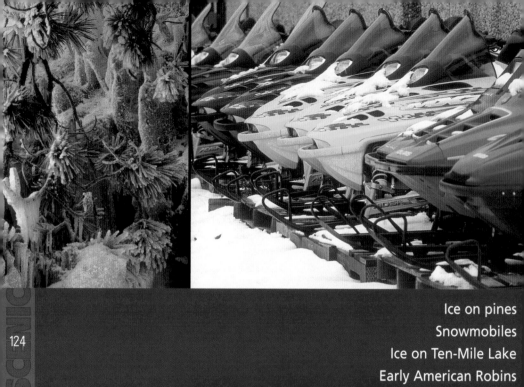

Ice on pines
Snowmobiles
Ice on Ten-Mile Lake
Early American Robins

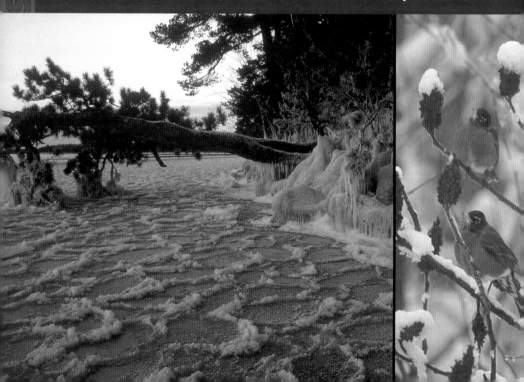

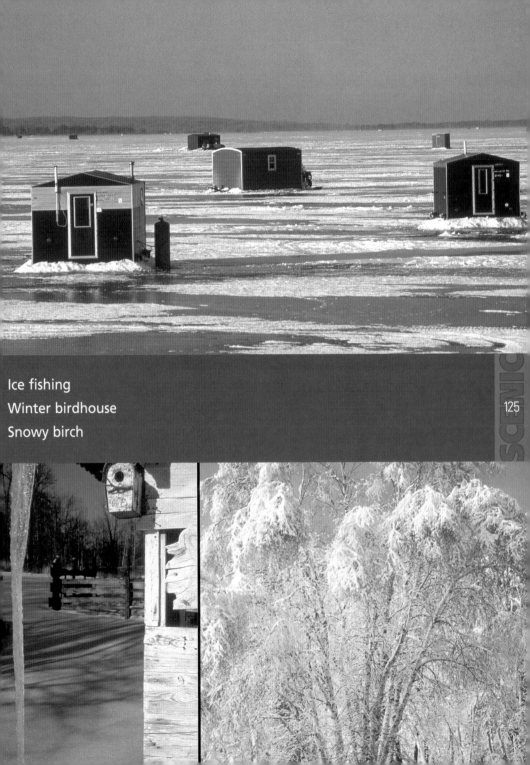

Ice fishing

Winter birdhouse

Snowy birch

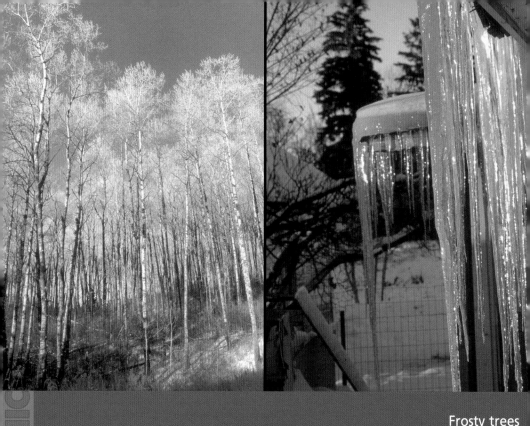

Frosty trees
Heavy icicles
The cabin up north

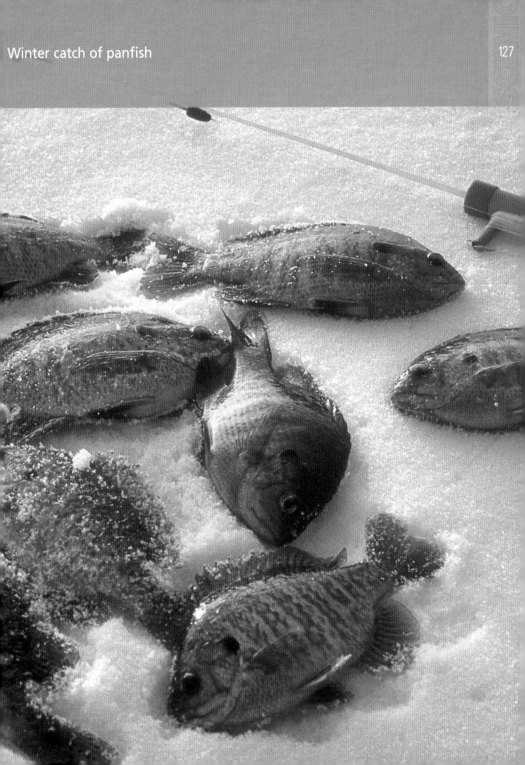

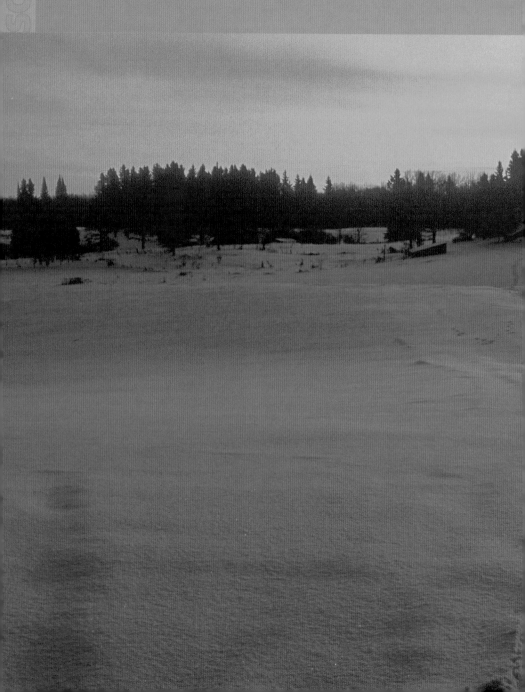

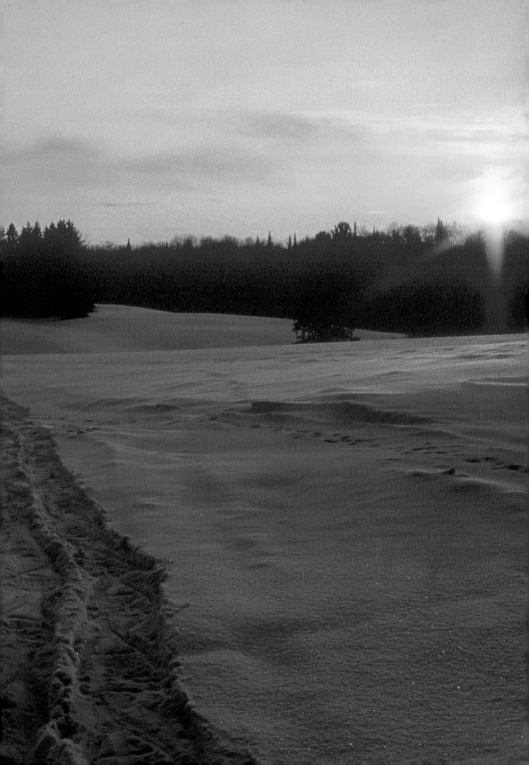

*M*innesota's Prairie Grasslands

Pg. 11 (Barn south of Jasper on Hwy. 23)
This friendly face greets people heading north towards Jasper on Hwy 23.

(Glockenspiel, New Ulm)
New Ulm's glockenspiel is one of the world's rare free-standing carillon clock towers. As the town was established by many settlers from Ulm, Germany, its rich German heritage is reflected in this landmark.

(Prairie chicken monument, Rothsay)
Rothsay and surrounding areas have the largest concentration of prairie chickens in the state. Centered in grasslands and agricultural fields, their ideal habitat, Rothsay is the prairie chicken capital of Minnesota.

Pg. 12-13 (Springtime in west central Minnesota)
In an average year, Minnesotans will endure seven months of snowfall, beginning in October and ending in April. The first colors of spring paint the dormant, brown landscape.

Pg. 14 (White-tailed Deer, Red River Valley)
Minnesota has about 1 million White-tailed Deer, making them the state's most popular wildlife species. They can be commonly spotted in the wooded areas of the Red River Valley. But since the species has easily adapted to farmland, deep woods, wet marshes and even metro areas of the state, they are found in every county.

(Sunflower field, Red River Valley)
The black, nutrient-rich soil of the Red River Valley provides some of the best farmland in the world. Although in 1997 the state was ranked fourth in the country for all sunflowers produced, this crop is not a main source of income for farmers. In fact, sunflowers only account for less than seven percent of the total cash receipts for farmers in Minnesota.

Pg. 15 (Minnesota River Valley, north of new Ulm)
The Minnesota River Valley Scenic Byway runs along the river, providing spectacular views from your vehicle. The byway begins in the town of Browns Valley and goes through to Belle Plaine.

(Corn crib in south central Minnesota)
Corn is one of the four principal commodities of the state, along with soybeans, hogs and dairy products, according to the 2000 U.S. Census Bureau. Corn cribs like this one allow the cobs to dry while they are stored.

(Corn picker in south central Minnesota)
The U.S. Department of Agriculture reported that 6.2 million acres of corn was harvested in 2001. Approximately 2.7 billion pounds of corn come from Minnesota alone.

Pg. 16-17 (Old Mill State Park, near Argyle)
This log cabin is one of many attractions to the park. The Middle River Valley running through the park ushers in a variety of birds and wildlife. This is also a prime area to allow your senses to experience the beautiful wildflowers that are native to the region.

Pg. 18 (Rough terrain near Granite Falls)
Granite outcrops like these are known as some of the world's oldest rocks.

(Big Ole, Alexandria)
Big Ole, weighing four tons and standing 28 feet tall, represented Minnesota at the World's Fair in 1965. Accompanying Big Ole on his trip to New York was the famous Kensington Runestone. This stone was found in a field close to Alexandria in 1898, with inscriptions of events dating back to the 14th century. This artifact, though its authenticity is strongly debated, explains Big Ole's shield, claiming his town as the "Birthplace of America."

(Old Mill State Park, near Argyle)
This old grist mill has been fired up once a year to grind flour and astound spectators.

Pg. 19 (Fort Ridgely State Park, near Fairfax)
Fort Ridgely was once a community made up of 300 soldiers and civilians, before it was twice attacked by the Dakota in the U.S.-Dakota Conflict of 1862. Besides a glimpse into Minnesota history, Fort Ridgely State Park also offers undisturbed open bluffs, showcasing the best displays of wildflowers and native grasses.

(Jolly Green Giant, Blue Earth)
The Minnesota Valley Canning Company of Blue Earth's neighborhood town, Le Sueur, adopted the Jolly Green Giant to help introduce their new canned pea. Inspired by one of Grimm's Fairy Tales, he has served as the trademark of the Jolly Green Giant Company since 1925. He is especially recognized for his catch phrase: "Ho Ho Ho Green Giant!"

(Agassiz National Wildlife Refuge, near Thief River Falls)
Comprised of 61,500 acres, the Agassiz Wildlife Refuge supports 280 species of birds and 49 species of mammals, including resident packs of Eastern Gray Wolves.This is one of only a handful of refuges in the lower 48 states that is known to harbor this species.

Pg. 20-21 (Minnesota River Valley, southwest of Fairfax)
The U.S. Department of Agriculture reported 1.8 million acres of wheat, equal to over 4.5 billion pounds, was harvested from the state in 2001.

Pg. 22 (Stavkirke, Moorhead)
This smaller replication of the original Hopperstad Stavkirke found in Vik, Norway can be seen at the Heritage Hjemkomst Interpretive Center in downtown Moorhead. It stands as a symbol representing the deep roots of Scandinavia and Christianity in the region. During the summer months it is used for special events, including weddings.

Pg. 23 (Wind farm, southwest Minnesota)
Minnesota has been one of the country's leaders in developing alternative energy sources to rapidly depleting oil supplies. A clean, renewable solution to the energy predicament blows through the air. According to the American Wind Energy Association, the state is ranked second in wind capacity. Some of the largest wind farms in the country can be spotted in southwest Minnesota.

(Glacial Lakes State Park, near Starbuck)
Take a step back in geologic history at this state park. Experience what is Minnesota's original prairie, of which only one-tenth of one percent

remains. See the preserved rolling prairies in their most pristine condition, nurturing rare wildflowers and grasses.

(River Otter statue, Fergus Falls)
Fergus Falls is the proud home of the world's largest River Otter. As the county seat of Otter Tail County, this town is the beginning of the 150-mile long Otter Trail Scenic Byway, along which you can gain access to 1,000 Minnesota lakes and 23 historically or culturally significant locations.

Pg. 24-25 (Harvest time in southeast Minnesota)
In 2001, the U.S. Department of Agriculture reported that there were 29 million acres of Minnesota farmland. The state is ranked sixth in the nation for total farm marketings, according to the 2000 U.S. Census Bureau.

Pg. 26 (Pipestone National Monument, near Pipestone)
For centuries, the Native Americans quarried the soft, red stone called pipestone from this area. This reserve was created by Congress in 1937, in order to protect the sacred pipestone quarry.

Pg. 27 (Pipestone National Monument, near Pipestone)
Native Americans continue to have exclusive rights to the removal of pipestone, from which they carve pipes for artistic, ceremonial and religious purposes.

(Pelican statue, Pelican Rapids)
The world's largest pelican stands 15 1/2 feet tall. Fish falling helplessly over the Mill Pond Dam are spared by the large bird statue, but not by people with fishing rods in hand, as this is a popular fishing spot for humans and pelicans alike.

(Minnesota River, Granite Falls)
The beautiful landscape in and around Granite Falls is why the town was dubbed "The Scenic City of the Valley."

Lake Country

Pg. 29 (Haying season, near Pine River)
Since dairy products are some of Minnesota's principal commodities, the production of quality hay is of great importance to feed the livestock. In 2001, 6.2 million tons of hay were harvested from 2.2 million acres of land in the state.

(Lindbergh State Park, Little Falls)
Charles A. Lindbergh, Jr. completed the first trans-Atlantic solo flight in 1927, which earned him the title of Little Falls' most famous native son. Within this park along the Mississippi River, visitors can see where he spent his boyhood. The park was actually named after the famous aviator's father, Charles A. Lindbergh, Sr., whose accomplishments as the progressive Republican Congressman representing central Minnesota from 1907–1917 cannot be understated.

Pg. 30 (Lindholm Oil Company Service Station, Cloquet)
This Phillips 66 gas station transcends the ordinary functional to the aesthetically admirable, conceived by artist and architect Frank Lloyd Wright. Built in 1958, Wright originally designed this prototype for his Broadacre City proposals of the 1930s. This was the only one built from his drawings. It is composed of cement block, cypress wood, glass and steel, and features a cantilevered copper canopy.

(Jacob V. Brower Visitor Center, Itasca State Park, north of Park Rapids)
Itasca State Park is Minnesota's oldest state park, thanks to the efforts of Jacob V. Brower. In the late 1800s, he saw the pine forests rapidly depleting by way of the logging industry, and was determined to protect what

was left. In 1891, his conservation work paid off; the state legislature established the remaining pine forest surrounding Lake Itasca as a Minnesota State Park, by a margin of one vote.

Pg. 31 (Abandoned open pit mine, Iron Range, northeast Minnesota)
For over 50 years, the Iron Range provided iron ore that fed the nation's steel mills. Mining became the backbone of northeast Minnesota's economic uprising. Beginning in the early 1890s, immigrant workers flocked to the three ranges–the Vermilion, the Mesabi, and the Cuyuna–thus creating the cultural diversity of the region.

Pg. 32-33 (Lake Country, north central Minnesota)
The state's pride and joy is its beautiful lakes, especially in Lake Country–an area that Minnesotans and visitors especially love to gather to enjoy every outdoor activity imaginable. The Lake Country Scenic Byway showcases the beauty of this area, running near or through national and state forests, a wildlife refuge and a state park.

Pg. 34 (Walleye tournament on Leech Lake in Walker)
The Mercury Walleye Classic on Leech Lake is held annually in the beginning of June, where fishermen can take advantage of the lake's strong and consistent Walleye fishing. While in Walker, anglers can visit the new home of the Minnesota Fishing Hall of Fame. The facility displays the deep devotion to one of Minnesotans' favorite pastimes.

(Paul Bunyan, Brainerd)
Minnesotans familiarize their children with the tall tales of Paul Bunyan. The giant lumberjack's legendary story originated in the bunkhouses of the Northwoods loggers, and as the tale was passed down through the generations, exaggeration of Paul and his blue ox Babe's features became the most memorable. Among a myriad of things for which he was responsible, he created the state's 10,000 lakes with his footprints.

(Ironworld, Chisholm)
Chisholm is the centerpiece of Minnesota's Iron Range, and home of the Ironworld Discovery Center. People in search of a fun and educational experience will find here exactly what they are looking for. The Center features living exhibits in the museum, rides into the Glen Mine, even a mini-golf course. The Iron Range Research Center is also at Ironworld, focusing on the history and genealogy of the immigrants who settled in the area to work the mines.

(United States Hockey Hall of Fame, Eveleth)
Known as "The Capital of American Hockey," it is fitting that Eveleth is home to the United States Hockey Hall of Fame. Besides producing some of the sport's most quality players, this small community's contributions to the growth and development of hockey are unprecedented. Visitors can learn about the lives and outstanding achievements of the 107 enshrined contributors to the game.

Pg. 35 (Itasca State Park, north of Park Rapids)
This park is composed of over 32,000 acres, on which rests 25 percent of Minnesota's remaining old growth pine. Visitors traveling down Wilderness Drive will pass one of the state's seven National Natural Landmarks: the 2,000-acre Wilderness Sanctuary.

(Orr's welcome sign)
Pelicans hunting for the abundant bluegills, crappies, walleyes, and Northern Pike in the relatively shallow waters of Pelican Lake (hence the name) make the unique sight a good reason to visit the Orr area. Visitors must take advantage of The Vince Schute Wilderness Sanctuary, deemed as one of the best places to see wild black bears in the United States. Orr offers outstanding hiking, fishing and camping opportunities as well.

(Judy Garland's house, Grand Rapids)
"Baby" Francis Gumm, later known as Judy Garland, was born in 1922 in Grand Rapids. Garland was in 35 films in her career, but best known as Dorothy in *The Wizard of Oz*. Her childhood home was restored in 1996, in time for Judy's 75th Birthday Celebration in the summer of 1997. The house is adjacent to a one-acre theme garden that is reminiscent of the classic movie, complete with a field of red poppies.

Pg. 36 (Giant Walleye near Mille Lacs Lake in Garrison)
There is no better place to look for Walleye than Mille Lacs Lake, which is often called "The Walleye Capital." As one of the state's top Walleye producers, Mille Lacs harbors around 1 million catch-and-keep Walleyes and produces a harvest of 200,000 to 400,000 Walleyes each year.

Pg. 37 (Charles Lindbergh's boyhood home, Little Falls)
Charles Lindbergh won the Congressional Medal of Honor for his solo flight across the Atlantic in 1927, and won the Pulitzer Prize in literature for his autobiography, *The Spirit of St. Louis*. Gain perspective on the Lindbergh legacy from visiting this 1906 house, containing original furnishings and family possessions.

(Voyagaire Lodge on Crane Lake)
Voyagaire Lodge can be found right on the shores overlooking the beauty of Crane Lake and Voyageurs National Park. Beyond the typical summer fun provided by lakes in Minnesota, such as boating and fishing, Crane Lake claims some other favorite activities include berry picking and stargazing. In the winter, snowmobiling, cross-country skiing and snow-shoeing are very popular on the area's trails.

(Voyageurs National Park)
This national park was named after the French-Canadian men who traveled in their birch bark canoes through the waters of the Great Lakes into the interior of the western United States and Canada. Consisting of nearly 80,000 acres of water, boat was the only way to get around. Today, with less than 10 miles of roads, it is a boater's paradise. Visitors must leave their cars behind for a motorboat, canoe, kayak or sailboat; all campsites are accessible by water only.

Pg. 38-39 (Paul Bunyan and Babe the Blue Ox, Bemidji)
Bemidji is the home of the original Paul and Babe statues, built in 1937. The largest ox in the area and Earl Bucklen, the mayor at the time, served as the models for the statues, in which all measurements were scaled up three-to-one. Standing tall on the shore of Lake Bemidji, this site is listed on the National Register of Historic Places.

Pg. 40 (Headwaters of the Mississippi River, Itasca State Park, north of Park Rapids)
At the heart of America runs the Mississippi River, and at the heart of Itasca State Park is where it all begins. Minnesota's oldest state park is the origin of the longest river in the country. Spanning only 12 feet wide in some areas, visitors can actually wade across the mighty Mississippi's humble beginning.

(The Red Bridge, Park Rapids)
The Red Bridge is a delightful piece of the walking/biking trail next to the Heartland Park. Walkers and bikers can explore further on the Heartland Trail, which extends from Park Rapids, through Walker, and ends in Cass Lake.

(Logging in northern Minnesota)
Forests cover over one-third of the total land area in the state. Minnesota's logging industry, as important as it is to the state's economy, still follows parameters that preserve old growth, as well as forest-dependent mammals and birds.

Pg. 41 (Autumn in northern Minnesota)
Throughout the northern part of the state, a rainbow of foliage is truly a spectacular view. Gorgeous autumn colors are a sign that the long Minnesota winter is quickly approaching.

Pg. 42-43 (Sunset on first ice, Gull Lake, Brainerd)
Gull Lake is one of 465 lakes in the Brainerd area. The first sign of ice on the lake arouses the anticipation of snowmobilers as they wait patiently for the sheets to thicken before their first track can be imprinted.

Pg. 44 (Fall Lake, near Ely)
The outdoorsman visiting Ely can take advantage of access to the Boundary Waters Canoe Area Wilderness in any season. The area grants seclusion in the wilderness if desired, but Ely also offers a balance of cultural connections to music, art, literature, dance and theatre. The perfect blend of solitude and society helps draw in many artists, photographers, writers and adventurers to adopt Ely as home.

Pg. 45 (International Wolf Center, near Ely)
The International Wolf Center, a multi-million dollar facility, is designed to allow visitors to examine the nature of the wolf–one of the most elusive and misunderstood animals in the world. Visitors learn from exhibits, videos and demonstrations inside the complex. They are also encouraged to venture outdoors to a more interactive level with the creatures; participants can track wolves by plane, go on evening howling expeditions, or follow their tracks on snowshoes.

(Entrance to the Superior National Forest, Laurentian Divide, near Virginia)
The Laurentian Divide marks the boundary between the Red River and Rainy River basins from the Minnesota River and Lake Superior basins. Streams on the north slope flow to Canada, and streams on the south side flow south to Lake Superior or to the Gulf of Mexico via the Mississippi River. Before entering the Superior National Forest, this recreation area serves as a trailhead of more than 16 kilometers of winding scenic trails.

(Back roads of northern Minnesota)
This is a common sight for many months in Minnesota. The state receives an average of 59 inches of snow per year. But once the last of the new fallen snow has blanketed the roads, it takes an average of 7.3 hours for all lanes to be completely cleared, according to the Minnesota Department of Transportation. The snow removal budget hovers around $115 million per year at the township, county and state levels combined.

Pg. 46-47 (Mississippi River, Itasca State Park, north of Park Rapids)
The abundance and variety of vegetation in the state park region support numerous wildlife species. Thousands of years ago, Native American hunters were able to thrive off the bountiful land, pursuing such wildlife as bison, deer and moose as they gathered at watering sites.

Pg. 48 (Grooming snowmobile trails, northern Minnesota)
There are 200,000 miles of groomed snowmobile trails in the state that boasts a $1 billion snowmobiling industry. This machine was invented in the 1950s by Polaris Industries of Roseau, Minnesota. They've caught on; close to 300,000 snowmobiles are registered in Minnesota.

(Bobber water tower, Pequot Lakes)
The legend continues: Paul Bunyan and his blue ox Babe tried to catch Notorious Nate, a mean, 40-foot northern pike. With the help of his bobber, measuring 60 feet around, he hooked Nate. As Paul tugged, Notorious Nate gave one last desperate flip in the air so high he landed seven miles away in downtown Pequot Lakes. The bobber landed where it remains today, high on the water tower to remind people of the battle between Paul and Nate.

(Babe the Blue Ox, Brainerd)
As a calf, Babe was rescued from drowning during the Winter of Blue Snow by legendary hero Paul Bunyan. Babe became Paul's workhorse and companion as he lumbered the great Northwoods of Michigan, Wisconsin and Minnesota. Statues of these characters are found in Brainerd, which was part of Paul's logging territory.

Pg. 49 (First ice on Lost Lake, near Hackensack)
Hackensack is at the heart of Minnesota's Lake Country. There are 127 lakes within a 10-mile radius of the town, including Lost Lake. Hackensack is the home of Lucette, Paul Bunyan's sweetheart, and their son, Paul Jr. Visit them on the shore of Birch Lake in Hackensack during Sweetheart Days, held every second week in July.

Pg. 50-51 (Railroad tracks in the snow, Brainerd)
The railroad has played an important role in Brainerd's growth and economy. In 1870, the Northern Pacific Railroad's survey determined that its Mississippi River crossing should be located in this budding community. As the city grew, it gained a prominent status as the center of the railroad and wood products in the region. To this day, the region's largest manufacturer is Brainerd's Missota Paper Company (formerly Potlatch Paper Company), and the railroad ranks as the city's twelfth largest employer.

Pg. 52 (Storm clearing over north central Minnesota's Lake Country) Approximately two thirds of the average 18–32 inches of annual precipitation falls during the warm months of May through September. But in Minnesota, the word "average" alludes to climates ranging from one extreme to the other. Because of its proximity to the Gulf of Mexico's warm air masses and to the cold Arctic cold masses, the state is at their crossroads. This means that drought and flood are as much of the climate as "normal" weather.

(Sunset on Leech Lake's Walker Bay)
Leech Lake is one of Minnesota's largest lakes. Walker, built on the shores of this lake and located in the heart of the Chippewa National Forest, was founded in the 1890s after the railroad line had been built from Brainerd.

(Historic water tower, Brainerd) The Brainerd water tower is one-of-a-kind. It took four years to complete the 134-foot tower, but from 1922 to 1958 it stored the entire city's water supply of 300,000 gallons. It was made with a single pour of cement–one of only a few in the world that were built this way.

Duluth and Lake Superior's North Shore

Pg. 54-55 (Lighthouse, Grand Marais)
For years Grand Marais, which translates to "large harbor," was the safe haven the Chippewa and Voyageur peoples sought to escape the crashing waves of Lake Superior. Settlers in the 1880s looked to take advantage of fishing and logging opportunities. The Army Corps of Engineers sought to accommodate them, constructing two piers with the light and fog signal guiding mariners between the piers.

Pg. 56 (Lake Superior's North Shore)
The Great North Shore Drive on Highway 61 teeters between land and water, showcasing beautiful, endless landscapes throughout every season. Highway travelers can take their time to make sure they don't miss anything, stopping for the night to enjoy fine dining and plush accommodations, or campfire food in a cozy campground.

Pg. 57 (Aerial Lift Bridge, Duluth)
The Aerial Lift Bridge, built from 1929–1930, was the architectural solution to transporting vehicular and pedestrian traffic from one side of the Duluth Harbor to the other, without blocking the water channel for large vessels. Before the bridge was built, people of Duluth traveled back and forth by way of ferries in the summer and temporary bridges in the winter when the port was frozen.

(Silver Bay Marina)
The U.S. Army Corps of Engineers and the Minnesota Department of Natural Resources teamed up to construct the Silver Bay Marina, completed in 1999. It is the first harbor of refuge or marina to be built on

141

the North Shore of Lake Superior, providing 61 slips with expansion in mind for the future.

Pg. 58 (Glensheen Mansion, Duluth)
In 1908, mining millionaire Chester Congdon finished building this estate on 7.6 acres for his wife and six children. Willed to the University of Minnesota, the 39-room Glensheen is one of the state's most remarkable historic gems. A majority of the original furnishings are intact, down to the children's clothing in their closets. The site closely resembles what it looked like when the Congdons moved in, making this attraction a time capsule, holding hundreds of museum-quality examples of the best work of the time. Since opening for tours in 1979, over 2 million people have visited the mansion.

Pg. 59 (Lake Superior's Shoreline)
Get lost in the magnificence of the scenes along the North Shore. There is plenty to do: bird watching or rock climbing, walking, hiking or marathon running. Duluth is home to world-renowned Grandma's Marathon, which draws more than 9,000 participants from around the globe every year in June. The 26.2-mile stretch begins on Old Highway 61, just outside of Two Harbors, Minnesota, and finishes in Duluth's Canal Park, adjacent to the world-famous Grandma's Restaurant.

Pg. 60-61 (Shovel Point, Tettegouche State Park, near Silver Bay)
Tettegouche is a hiker's paradise. Miles of trails overlook the Sawtooth Mountains, wind down to the inland lakes, curl up to spectacular views at Shovel Point, and cascade down by the 60-foot falls of the Baptism River. There is also an abundance of opportunities to bird watch, fish for trout, and rock climb.

Pg. 62 (Split Rock Lighthouse State Park, near Two Harbors)
In 1905, Lake Superior delivered a November gale that led to the unfortunate sinking of the *Edenborn* and the barge it was towing, the *Madiera*, along with five other ships within 12 miles of the Split Rock River. After the construction of the highly demanded Split Rock Lighthouse in 1909, ships were warned away from the treacherous rocks of the North Shore by its 370,000-candlepower beacon. To this day, it is one of the most photographed lighthouses in the country.

Pg. 63 (Rose Garden in Leif Erikson Park, Duluth)
A grand, full-scale replica of a wooden Viking ship used by the Norse sailor Leif Erikson is the centerpiece of an arrangement composed of 3,000 rosebushes and other flowers. The park is complete with benches

where visitors can feast their eyes on the view of the lake, while their noses take in the sweet smells of the garden.

(Hawk Ridge Nature Reserve, Duluth)
The Hawk Ridge Nature Reserve is a hot spot for some of North America's best autumn hawk watching. The systematic counting began in 1972; from August to December and from dawn to dusk, a counter is at the ridge, recording every hawk that passes. Hawks migrate from the Arctic to as far as South America, but as they approach Lake Superior, they funnel down along the bluffs of the North Shore, reluctant to cross the huge body of water.

(Great Lakes Aquarium, Duluth)
This 62,000-square-foot aquarium is home to 70 species of fish, as well as birds, reptiles, amphibians and river otters. It is the only freshwater aquarium in the country, but also is unique as a natural history center, a science center and a cultural history center.

(Silver Creek Tunnel on Hwy. 61, near Two Harbors)
Completed in 1995, this 1,400-foot tunnel burrows through Silver Creek Cliff, a volcanic rock formation. The Silver Creek Tunnel replaced a narrow, steep and dangerous two-lane highway that ran along the side of the cliff. This grand, award-winning addition to the nationally acclaimed North Shore driving experience is the second tunnel built on Scenic Highway 61.

Pg. 64-65 (*U.S.S. William A. Irvin*, Duluth) The president of the U.S. Steel Company named his fleet's flagship after himself. The *Irvin* was the first freighter built on the Great Lakes after the Depression in 1938, at a time when freighter design was highly standardized and conservative. Yet in order to attract new wealthy customers and to thank the regulars for their business, the *Irvin* incorporated many new technologies and lofty amenities such as a dining room, staterooms, shuffleboard and a driving range for golfers. These perks make this floating museum a sight not to miss.

Pg. 66 (Canal Park Lighthouse, Duluth)
You can't get much more inland than Minnesota, yet natives and visitors can get a sense of the ocean by spending the weekend in Canal Park. Feed the gulls while walking along the boardwalk. Watch the lighthouse guide ships through to the harbor beneath the Aerial Lift Bridge. With plenty of things to see and do, places to tour and restaurants all within walking distance, Canal Park is an enticing place to visit again and again.

(Duluth's harbor)
Vessels from all over the world grace the waters of Minnesota's ocean port. The world's longest freshwater sandbar separates Duluth's harbor from Lake Superior, through which ships export grain, taconite and cement. Totaling 12 miles, six miles of this sandbar belong to Minnesota, six to Wisconsin.

(Lower Falls, Gooseberry Falls State Park, near Two Harbors)
It has been determined that many years ago, the earth began to split along the area of the North Shore. Lava spilled out onto the earth and cooled to form volcanic bedrock. Some of these lava flows can be seen at the Upper, Middle and Lower Falls near the Gooseberry River. Known as "The Gateway to the North Shore," the Gooseberry River has appeared on explorer maps as early as 1670.

Pg. 67 (Sunrise over Lake Superior in Grand Marais)
Scenes like this of Lake Superior evoke artists' interpretations. Grand Marais is one of the country's top ten art communities and home to a large population of artists as well. The Arrowhead Center for the Arts lends support and means of expression through its Grand Marais Playhouse, the Grand Marais Art Colony and the North Shore Music Association.

(Gateway to the Gunflint Trail, Grand Marais) First used by the Ojibwe Native Americans, who resided in the area for thousands of years, the Gunflint Trail was originally an overland footpath used to travel from Minnesota's inland lakes to Lake Superior. The 63-mile long trail extends from Hungry Jack Lake to Poplar Lake, to Gunflint Lake and the Cross River.

(Upper Falls, Gooseberry Falls State Park, near Two Harbors)
After the legislature authorized the preservation of Gooseberry Falls and its surrounding area, the Civilian Conservation Corps (CCC) began to develop this state park in 1934. They built the stone and log buildings, trails, original camping and picnic grounds, and the 300-foot long retaining wall, known as the "Castle in the Park."

Pg. 68-69 (Harbor at Grand Marais)
Grand Marais boasts of its legendary wolf population; the surrounding area is one of the most populated remaining wolf habitats in the contiguous states. Wildlife observers can also spot such species as moose, foxes, bears and eagles, to name a few.

Pg. 70 (North Shore of Lake Superior)
Lake Superior is the largest of the Great Lakes and has the largest surface area of any freshwater lake in the world. It contains 3,000 cubic miles of water, which could fill all other Great Lakes, plus three additional lakes the size of Lake Erie. The Great Lakes together hold about one-fifth of the world's fresh surface water supply and about 90 percent of the country's fresh surface water supply.

(Northwest Company Depot, Grand Portage National Monument)
The Northwest Company Depot is a fully restored fur trading post that did business from 1730–1805. It was the main entry point of European exploration and trade with the Native peoples into British Canada. Visitors can tour the grounds that include a great hall, a canoe warehouse, a fur press and a lookout tower. Two festivals celebrating the groups that traded at the Depot are held the second weekend in August: The Rendezvous Days Powwow and the Voyageur Rendezvous Festival.

(Historic Naniboujou Lodge, Grand Marais)
In the 1920s, this exclusive private club's roster of charter members included names such as Jack Dempsey, Ring Lardner and Babe Ruth. Naniboujou, brilliantly embellished with designs of the Cree, is a comfortable vacation spot abundant in beauty and history. Under new ownership, the Lodge has seen beautiful restoration, but not modernization; in order to preserve the aura of a time gone by and to uphold a sanctuary for visitors to escape from the outside world, phones and televisions are absent in Naniboujou's staying quarters.

Pg. 71 (Lutsen Ski Resort)
In a region where rolling prairies, farmland and forests dominate, Lutsen is the summit; it is Mid-America's largest ski resort, with the highest vertical rise at 1,088 feet. The unique beauty of the North Shore region adds to the experience. Small wonder Lutsen is often ranked as one of North America's most scenic ski resorts, with an inland sea in sight, a mountain backdrop, and surrounded by unspoiled wilderness.

(Winter on the North Shore of Lake Superior)
Lake Superior is the deepest of the Great Lakes, averaging a depth approaching 500 feet and the deepest point reaching 1,332 feet. This makes Superior the coldest Great Lake as well; the water is relatively cold year-round and will freeze over in the winter. Yet, air over a lake will cool slower than air over land. Cold fronts that move over and mix with the relatively warmer air over the lake will produce what is called "lake effect

snow." This snowfall contributes between 30–50 percent of the annual winter snowfall in the areas east and south of the lake.

(Lighthouse at Two Harbors)
Listed in the National Register of Historic Places, this lighthouse began round-the-clock operation in 1892 and is still going strong. It is the oldest operating light station on the North Shore as it guides ships into Agate Bay to fill up with taconite.

(John Beargrease Sled Dog Marathon along Minnesota's North Shore)
Otherwise known as the "pilot of Lake Superior," John Beargrease, born in 1861, was the son of a Chippewa Chief and a member of the Grand Portage Chippewa band. From 1887–1900 he built his legacy by delivering mail up the North Shore between Two Harbors and Grand Marais. He was instrumental in the development of the North Shore, and for many, his weekly deliveries were the only link to the outside world.

Pg. 72 (John Beargrease Sled Dog Marathon, Finland Checkpoint)
Using four sled dogs but no overland trails or bridges over rivers or streams, John Beargrease's fastest time one-way was 20 hours from one delivery checkpoint to the other. Every year, racers are inspired and driven by his impressive delivery accomplishments. The John Beargrease Sled Dog Marathon is a tribute to his memory, and celebrates the powerful spirit that thrives along the North Shore.

Metro Area

Pg. 74 (Minneapolis)
It has been said that Mark Twain was the first to call Minneapolis and St. Paul "The Twin Cities"–a mere 12 miles separate them as they straddle the Mississippi River. Minneapolis became a major processing center for wheat from the northern prairies shortly after statehood was granted in 1858. The birth of mega-businesses General Mills, a cereal company, and Pillsbury, a pastry company, led Minneapolis to become the world's flour-milling capital by the 1920s. These giants collectively were the backbone upon which the city built an industrious, prosperous and culture-rich metropolis that is still booming today. The buildings in this photo listed from left to right: the Gold Step Pyramid (now the Wells Fargo building), the IDS Tower, the Target Corporation Building and the Basilica.

(*Jonathan Padelford* riverboat, St. Paul)
Captain William D. Bowell, Sr. founded the Padelford Packet Boat Company in 1969 with the launching of the *Jonathan Padelford*. This replica of an 1880 sternwheel riverboat was named after one of Capt. Bowell's great grandfathers. His niece wanted her wedding reception on board the *Padelford*, thus propelling Bowell into the charter business. Since then the company has added ships to its fleet and has hosted thousands of private parties on the Mississippi River.

Pg. 75 (Entrance to the Minnesota Zoo, Apple Valley)
Since 1978, the Minnesota Zoo has been able to offer award-winning recreational, educational and conservation programs locally, nationally and internationally. The Zoo's current capacity is around 2,300 animals, 105 of them representing 15 species on the United States Endangered

Species List–the bald eagle, puma, green sea turtle and the red panda, to name a few.

(The Marjorie McNeely Conservatory at Como Park, St. Paul)
This fantastic half-acre glass and steel conservatory was built in 1915 and stands today as the largest glass-domed garden in the region. It was named after the late Marjorie McNeely in 2003, who was the president of the St. Paul Garden Club and a member of the original Guthrie Theater board. Among higher prestigious awards, the locals have recognized the conservatory as "The Best Place for a First Date," and "The Best Place to Relieve Holiday Stress."

Pg. 76 (The Minneapolis Institute of Arts)
The Minneapolis Institute of Arts (MIA) was established in 1883. McKim, Mead and White were commissioned to design the original neoclassical building, which opened in 1915. In 1974, Japanese architect Kenzo Tange designed the additions. Designer and architect Michael Graves will soon harmonize all three styles of architecture with his expansions, as the MIA's collection exceeds 100,000 objects from diverse cultural traditions spanning more than 5,000 years of world history.

(Minneapolis-St. Paul International Airport)
In 1914 the land that is now the Minneapolis-St. Paul International Airport (MSP) used to be Snelling Speedway, an unsuccessful auto-racing venue that the Minneapolis Aero Club visionaries saw as valuable for other purposes. Now tallying a half-million takeoffs and landings each year, MSP is one of the world's busiest airports. MSP ranks near the top of U.S. airports in numbers of passengers and operations.

(Mall of America, Bloomington)
To live in or visit a state that is famous for its extremes in temperatures, what mode of entertainment tops shopping, or better yet, shopping in 520 stores under one roof? Since opening in 1992, the Mall of America plays host to 35 to 42 million visitors annually. Over 56 million rides have been given at Camp Snoopy, located at the seven-acre core of the Mall. The largest tourist attraction in the state is also one of the most visited destinations in the country, attracting more visitors than Disney World, the Grand Canyon and Graceland combined.

Pg. 77 (Ordway Center for the Performing Arts, St. Paul)
The Ordway Center was the baby of Sally Ordway Irvine, who envisioned a cultural hot spot for theatre, musicals, operas and concerts. Private donors paid the $46 million it cost to build, and it opened in 1985 with

national acclaim. The Ordway is a nonprofit organization that sees 35,000 visitors yearly. A majority of those visitors arrive in school buses from the public schools in Minneapolis and St. Paul. These public schools visit the Ordway Center more than any other field trip destination in the Twin Cities, proving the organization's dedication to the cultural enrichment of children.

(The Minneapolis Institute of Arts)
The Minneapolis Institute of Arts (MIA) makes it possible for everyone to engage their artistic minds—one of the reasons why the Twin Cities has a high awareness of the arts. Over 560,000 visitors in 2002 took advantage of the MIA's free admission, which they offer every day. The Ford Motor Company sponsors Ford Free Sundays, in which families can partake in various activities including tours, interactive learning stations and performances all designed to arouse the artist in everyone at an early age.

(Minnesota's capitol, St. Paul)
Cass Gilbert, commissioned in 1895, designed this architectural masterpiece. This is Minnesota's third capitol building, which is located in downtown St. Paul. Guided tours allow access to view original furnishings and restored chambers of the House, Senate and the Supreme Court. This state capitol has the world's largest unsupported marble dome, which Gilbert modeled after Michelangelo's dome on St. Peter's in Rome.

Pg. 78-79 (Historic Mickey's Diner in St. Paul)
Old Mickey's Diner hasn't changed much since it opened in 1939. Amid the stark buildings of today, it has often been used as a metaphor to describe St. Paul in its relationship to Minneapolis. It has been argued that Minneapolis is the buzzing cosmopolitan, while St. Paul is smaller and quieter, which gives it a more hometown feel. To visitors, it is hard to discern one city from the other. This discussion would be good over one of Mickey's old-fashioned malts.

Pg. 80 (Cafesjian's Carousel, Como Park, St. Paul)
This carousel originally ran at the Minnesota State Fair from 1914 to 1988. When news broke out that the privately-owned carousel would have to be auctioned off, Peter Boehm and Nancy Peterson, a couple from St. Paul, dedicated time and energy to keep it in Minnesota. They raised the $1.1 million from continuous carousel revenue and donations. A mystery donor, who was later identified as Gerard L. Cafesjian, contributed $600,000 towards the cause. The copper-roofed pavilion in Como Park, housing the restored carousel, was named after him in gratitude.

Pg. 81 (Lake Harriet Rose Garden, Minneapolis)
Built in 1907 and 1908, the Lake Harriet Rose Garden is the second-oldest public rose garden in the country. Come during blooming season from mid-June to late September to see breathtaking botanical views. The Heffelfinger Fountain, found on the upper patio, as well as the official All-America Rose Selections (AARS) test rose garden make this attraction worth the visit.

(University of Minnesota Bridge, Minneapolis)
The University of Minnesota has four campuses statewide. The classic Big Ten campus, with its state-of-the-art facilities amidst stately historic buildings, is located in the Twin Cities. This university is ranked as one of the most prestigious in the country. Two-thirds of the state's doctors, veterinarians, dentists and pharmacists earn their degrees here.

Pg. 82 (The Minnesota Landscape Arboretum, Chanhassen)
The Arboretum is part of the Department of Horticultural Science within the College of Agricultural, Food and Environmental Sciences at the University of Minnesota. It is open to the public, offering daily educational opportunities to adults and children while conducting horticultural research on a regular basis. It also features a horticultural library, conservatory, tearoom and gift shop.

Pg. 83 (Cathedral of St. Paul)
The diocese that originally served the territories of Minnesota and the Dakotas was established in 1850, and became an archdiocese in 1888. The Archdiocese of Minneapolis and St. Paul has 222 parishes and is home to 750,000 Catholics from the area, which equates to about 25 percent of the Twin Cities population.

(Lake Wobegon Store, Mall of America, Bloomington)
Out of over 15,000 lakes in the state, Lake Wobegon, USA is not one of them. In fact, it doesn't exist. One of the most famous destinations in Minnesota can only be pinpointed on the map in Bloomington, at the Mall of America. Author and host of Minnesota Public Radio's *A Prairie Home Companion,* Garrison Keillor tells stories about the essence of small town, Minnesota life. Gifts and collectibles that reflect his poignant and humorous ideas of local country flavor can be found here.

(The Minneapolis Institute of Arts)
The Minneapolis Institute of Arts is only one part of the artistic avenue on the southern end of the city. The Children's Theatre Company, where young people and families can gain experience in the performing arts, is

recognized as North America's flagship theatre. Many of the performances are adapted classic children's literature and storybooks. Minneapolis College of Art and Design, founded in 1886, is one of the finest art college facilities in the country. All three of these entities are on the same block in Minneapolis.

(Minnesota's capitol, St. Paul)
One of the state capitol's numerous wonders is highly visible from a distance. Daniel Chester French and Edward Potter sculpted the gold-leafed copper and steel statuary group standing high atop the building. The subjects of "Progress of the State" include four horses, representing earth, wind, fire and water. The women symbolize civilization, and the man on the chariot represents prosperity. Often referred to as the "Quadriga," this artwork was removed from 1994–1995 for complete restoration and gilding.

Pg. 84-85 (*Andiamo* paddlewheel riverboat, Stillwater)
Stillwater was the state's first city, established in 1848 as a community that thrived on the lumbering industry. The St. Croix Boat and Packet Company displays the pride of the town's meticulously preserved history. The *Andiamo* is one paddleboat in the Company's fleet of eight that can accommodate large outings on the St. Croix River.

Pg. 86 (Fort Snelling State Park, St. Paul)
Before the Europeans arrived in the late 1600s, the Dakota people lived in villages along the Minnesota and Mississippi rivers that met in what is now Fort Snelling State Park. Bands of the Dakota believed that the river convergence was the place of origin and center of the earth. Spend a day at Fort Snelling and hike, bike or cross-country ski the trails that connect this state park with Minnehaha Park and the Minnesota Valley National Wildlife Refuge.

(Minnehaha Falls, Minneapolis)
New England poet Henry Wadsworth Longfellow needed only pictures of the 53-foot waterfall to be inspired to write "The Song of Hiawatha" as a tribute to the Native American spirit. The Minnehaha Falls Park features the Longfellow House Hospitality Center, the Grand Rounds, which is a 50-mile outdoor recreation loop around the Minneapolis area, the John H. Stevens Museum, the Princess Depot and the Minnehaha Falls Off-Leash Dog Park.

(Cathedral of St. Paul)
Designed by French architect Emmanuel Masqueray, the cathedral was similarly styled as St. Paul's Cathedral in Rome, and opened for its first services in 1915. Exterior walls of the structure are made of Rockville Granite from St. Cloud, Minnesota. The interior walls are American Travertine from Mankato, Minnesota. Inside the Shrine of the Nations, six chapels are dedicated to the national patron saints of many of the immigrants that settled in the area, including the Irish, French Canadian, Slavs, German, Italian and missionaries from around the world.

Pg. 87 (Science Museum of Minnesota, St. Paul)
Minnesota's most popular museum has eight acres of exhibits. Permanent attractions include the Human Body Gallery, complete with Cell Lab and Bloodstream Superhighway, the Dinosaurs and Fossils Gallery, and the Experiment Gallery, where people of all ages can learn through hands-on exhibits. The Museum's omnitheater is the first convertible dome in the country, and its 3-D laser show is the tenth of its kind in the world.

(Minnesota History Center, St. Paul)
The History Center Museum is another of the Twin Cities' architectural marvels, made out of the state's native materials. It showcases a great lookout of the city, and provides a day of discovery and enlightenment for the whole family. Learning is never boring with engaging modes of education, such as the Museum Theater and the "History a la Carte" hands-on exhibits.

Pg. 88-89 (Pumpkins, Belle Plaine)
Minnesota Territorial Judge Andrew G. Chatfield chose this town site nestled in the Minnesota River Valley in 1853, while traveling on horseback. He named the town Belle Plaine, which is French for "beautiful prairie." Located between the Twin Cities and Mankato, Belle Plaine serves as the southwest gateway to the metro area.

Pg. 90 (Autumn sidewalk, Hastings)
Hastings, founded in 1855, is another of the state's oldest communities. Many neighborhoods include tree-lined streets adorned with gorgeous Victorian homes. Needless to say, the Mississippi River, the St. Croix River bluffs, and the Vermillion Falls all add to the aesthetic magnificence of this small town, located south only 20 miles from St. Paul. Take a self-guided tour of Hastings on its many bike trails and walkways.

Pg. 91 (The Minnesota Landscape Arboretum, Chanhassen)
Strewn throughout the 1,000 acres of public gardens are miles of trails open to the public year-round. The Arboretum grows spectacular annual and perennial display gardens, collections of plants for northern climates, natural and native areas, and demonstration gardens, all through which visitors can hike in the summer and cross-country ski in the winter.

(Main gate, Fort Snelling State Park, St. Paul)
Fort Snelling was built in the 1820s to control exploration, trade and settlement on these waterways, and was established as a state park in 1962. To this day, picnic sites, a popular swimming beach, and river and lake fishing attract people to where the Mississippi and Minnesota rivers meet.

(Longfellow House, Minneapolis)
Though it dons his name, the 19th century poet Henry Wadsworth Longfellow never lived here. Instead it is a replica of his house in Cambridge, Massachusetts, scaled down two-thirds its size. Located in Minnehaha Park, the Longfellow House was built in 1907 for Minneapolis philanthropist and entrepreneur Robert F. Jones. It has served many functions since Jones has lived there, but is now a public information center about Minnehaha Falls and the Grand Round, the 50-mile recreational loop around the area.

Pg. 92-93 (St. Paul from Harriet Island)
The Harriet Island Regional Park in downtown St. Paul is named after pioneer schoolteacher Harriet Bishop. In 1900, Dr. Justus Ohage gave the island to St. Paul citizens to provide a public recreation area. Over the years, Harriet Island was home to many attractions, including a complete outdoor gymnasium, the city's first zoo, and free public baths. Visitors are now drawn to the public dock, the Ohage Great Lawn and the Harriet Bishop Playground, as Harriet Island Regional Park continues to serve Twin Cities' citizens today.

Pg. 94 (Holidazzle Parade, Minneapolis)
Each year starting the Friday after Thanksgiving and running until the end of December, downtown Minneapolis lights up with smiles. The Holidazzle is a 30-minute evening parade, featuring extravagant light displays, characters from fairy tales, bands, choirs, dancers and of course, Santa Claus. The Parade has been traveling down Nicollet Mall for 10 years, making this electrifying event a Midwest tradition that millions of people have witnessed.

Pg. 96-97 (Amish home near St. Charles)
The Amish have reaped the benefits of the richest farmland in southeast Minnesota and the geographical seclusion of the bluffs as they settled in the area. There is a good chance to see an Amish horse and buggy using the Amish Scenic Byway on Highway 52 between Preston and Prosper. About 700 Amish residents live in the area around Canton and Harmony and use this highway frequently.

Pg. 98 (Lake Pepin in Lake City)
The Lake City marina is the largest small boat marina on the Mississippi River, allowing many people access to one of the best sailboating lakes in Minnesota. Lake City is best known as the birthplace of water skiing. When he was just 18 years old, Ralph W. Samuelson invented the sport of water skiing off the shores of Lake Pepin in 1922. The community celebrates Water Ski Days the last weekend in June, which draws over 20,000 visitors every year.

(Covered bridge, Zumbrota)
Minnesota's last remaining covered bridge can be seen in Zumbrota. Built in 1869, the bridge was used for stagecoach traffic traveling between Dubuque, Iowa and St. Paul. It stretches 120 feet long and 15 feet wide, and is the centerpiece of the Covered Bridge Park, which features a giant playground, trails and campgrounds.

(Bluff Country near Red Wing)
Red Wing is a quaint, historic river town banked along the Mississippi River. It is known for its antiques, pottery and the Red Wing Shoe

Company. The entire downtown area was restored to its original turn-of-the-century richness. This community flanked by the bluffs was rated as one of the best small towns in America by *USA Weekend* magazine.

Pg. 99 (Mayo Clinic, Rochester)
In the late 1800s, Mayo Clinic blossomed from the frontier family practice of Dr. William W. Mayo and his two sons, William J. and Charles H. Mayo. In 1919, the Mayo brothers turned the Clinic's name and assets–including a bulk of their life savings–to a private, not-for-profit charitable foundation. The brothers believed that any earnings from the practice, beyond those needed to operate and perpetuate the Clinic, should be used for medical education and research. For years, Mayo has been ranked as a top hospital in the country.

Pg. 100-101 (Springtime fields, southeastern Minnesota)
On average, the planting season in Minnesota begins in May. Farmers in the southern part of the state will be out working the fields about the last week of April. Farmers also have to be patient in letting the snow melt and dry before heavy machinery can begin their toil.

Pg. 102-103 (Nerstrand-Big Woods State Park, Nerstrand)
Nerstrand bursts into color in the spring. It becomes a virtual wildflower garden, nurturing the hepatica, Bloodroot, Dutchman's Breeches and the rare Dwarf Trout Lily. Peeking its face in April, the Dwarf Trout Lily is a one-of-a-kind sight to see. It is listed on the Federal Endangered Species List, and can only be found in this park.

Pg. 104 (Cabela's, Owatonna)
The outdoor sportsman could spend the entire day at this 150,000-square-foot Cabela's, known as The World's Foremost Outfitter. This unique shopping experience is created by the hundreds of mounts on the walls, stuffed waterfowl hanging from the ceiling, and three aquariums stocked with fish native to Minnesota. The café serves not just soups and sandwiches, but buffalo and elk burgers as well. "The Tribute to the Sportsman" is an entire mountain displaying many types of game over which the avid hunter fantasizes.

(Bluff Country near Winona)
Take a drive through small towns and quaint communities clinging to the bluffs. The Historic Bluff Country Scenic Byway is an 86-mile route on Highway 16 between Dexter and La Crescent, south of Winona. Travelers can stop at many scenic, historic, cultural, natural and recreational destinations.

Pg. 105 (Mayo Clinic, Rochester)
Since the Mayo brothers began practice with their father, the Mayo Clinic's capacity has grown exponentially. The Clinic now occupies 13 million square feet–approximately 2.5 times the size of the Mall of America. In 2001, it received over 315,000 unique patients and 1.21 million outpatients. There are 1,544 physicians in practice at the Mayo Clinic in Rochester, administering treatments of virtually every medical and surgical specialty.

(Lake Pepin in Lake City)
When clams were found in Lake Pepin, a large clam industry sprouted. The pearls were harvested and the shells discarded until it was discovered that shells could be made into buttons, barrettes, sleeve links and other accessories. At one time, 400 pounds of clams were pulled from Lake Pepin daily, providing for two button factories. The pearls could be sold for as much as $3,500 each while the meat was sold to local farmers for hog and chicken feed.

(Bluff Country near Winona)
The stretch of highway north of Red Wing heading towards Winona is a premier destination in the country to spot an abundance of Bald Eagles. From November to March, the Eagles can be seen on the edge of the ice looking for their fill of fish. The Eagle Observation Deck in Wabasha, located between Red Wing and Winona, is an excellent lookout for the bird that is on the Federal Endangered Species List.

Pg. 106-107 (Bluff Country near Winona)
Winona was built on a large island in the Mississippi River. Because of its prime location, the town was a transportation hub and developed into one of the world's richest cities by 1900. The history of the town is still present; take a tour of the Watkins Company, celebrating 135 years of business in 2003, or the old Bub's Brewery Building, which is now a furniture store complete with rock tunnels where kegs used to be stored. Climb Sugar Loaf, the bare rock towering over the town, for an unforgettable view of the town and the Mississippi Valley.

Pg. 109 (Great Blue Heron standing in spring mist)
There are six species of herons that live in the state during the spring and summer, and twelve that live in North America. The Great Blue Heron is the largest, standing up to four feet tall. These birds can be seen standing at the water's edge in search of aquatic insects, crayfish, frogs and non-game fish.

(Yellow Lady's Slippers)
There are two varieties of Yellow Lady's Slippers that grow in Minnesota: a large variety and a small variety. The large variety has a large lip with brown- and green-streaked petals, while the small variety has a small lip with petals and sepals of a uniform dark red. They prefer moderate amounts of moisture, and can most often be spotted blooming late May to early June in wooded areas, swamps, and sometimes in roadside ditches.

(Common Loon, State Bird of Minnesota)
Minnesota has more Common Loons than any other state except Alaska. Most birds have hollow bones that make them light enough to fly, but these Loons have solid bones to help them dive through the water in search of food. They will dive as deep as 250 feet, and can stay underwater for as long as five minutes feeding on aquatic life, such as panfish, perch, trout, frogs and crayfish. The Loons' red eyes help them see underwater.

Pg. 110-111 (Rainbow over summer fields)
Farmers who anxiously check their fields after a summer storm hope the rainbow is a good sign. A typical growing season often fights the weather, be it a drought or flood, hailstorms or tornadoes. But if the

crops endure minimal damages from summer weather blitzes, farmers can reap the benefits of a bountiful harvest.

Pg. 112 (Showy Lady's Slippers, State Flower of Minnesota)
The Showy Lady's Slipper blooms in June and July and can be seen around the state in areas such as Isanti County and Lake Bemidji State Park in bogs, fens, swamps and drainages. Showys grow in the wild around the state, but if traveling in the Baudette area, head down Highway 11 west toward Warroad. One would be sure to see a bounty of pink and white blossoms growing in the ditches on this designated Wildflower Route.

Pg. 113 (Peeling bark on a Paper Birch)
The white bark of Paper Birches characterizes the woods of the North. Throughout history, the woodland dwellers have used Paper Birches to meet many different needs. Native Americans used the sap for a spring tonic, the bark to make canoes, medicine, containers for food and water, splints for broken limbs and covering for wigwams. Scandinavians used birch bark to weave shoes and backpacks. Today, campers use the dry bark for campfire kindling.

(Summer sunset)
The only thing that could ruin this serene sunset gaze is swatting the many bugs that attack at dusk. There are six different biting bugs in the state: black flies, deer flies, horse flies, stable flies, midges and mosquitoes. Mosquitoes, oftentimes jokingly named the state bird, are very abundant in Minnesota. There are 50 species of mosquitoes in the state, and 28 of those bite humans. They lay their eggs on stagnant water, making adequate drainage very important to reduce hatching.

Pg. 114-115 (Common Loon, State Bird of Minnesota)
On land, with its legs set far back on its body, the Common Loon has an awkward gait, whereas they are extremely agile on the water. Their black bill and red eyes characterize them. In the summer look for the spotted black and white coat, with a black and green iridescent head. In the winter its plumage consists of gray feathers with an underlying white coat.

Pg. 116-117 (Autumn on a country road)
There are twenty Scenic Byways that have been designated by the state as scenic, cultural, historic, natural, recreational and archeological points of interest. The Minnesota system totals close to 1,600 miles. Travelers can see Minnesota and the country at its finest; of those twenty Byways, four are National Byways, and one–the North Shore Drive–is an All-American Road.

Pg. 118 (Autumn maple)
There are seven different varieties of maple trees present in Minnesota: the Amur, Mountain, Red, Sugar, Black, Silver and Norway. They are partly responsible for the beautiful colors that make an autumn drive around the countryside worth the trip.

(Sportsman's collection)
There are 2.3 million licensed anglers and 453,000 licensed deer hunters in Minnesota. Combined, there are over a half million licenses issued per year for small game, waterfowl or pheasants in the state.

(Autumn on Leech Lake)
There is one boat for every six residents in the state–the highest boat per capita in the country.

Pg. 119 (Autumn fishing trip)
Lake trout season ends late in September, granting anglers a few fishing weekends on a serene autumn lake. It also gives them a few more chances to catch "the big one" left over from the summer.

(Autumn on Leech Lake)
The Leech Lake area is surrounded by the Chippewa National Forest. The autumn trees burst with color; the bright yellows, blazing reds and vibrant oranges are twice as nice in the lake's reflection.

Pg. 120-121 (Old horse barn)
Horses were an essential part of life in the 1800s and early 1900s. Horses and oxen provided much of the power to get farm chores done. Transportation was centered on the utilization of horses; they drew buggies from town to country, and trolleys in the urban areas. The Minnesota State Fair, which runs for ten days before Labor Day, is one of the best places to see how important horses were in that era.

Pg. 122 (Autumn morning)
The Tamarack tree is a highly unusual species. Unlike the rest of its ever-green pine family, it behaves like a deciduous tree and loses its leaves in autumn. The Tamarack, as the one centered in this picture, has needles that turn a bright golden yellow before they are shed.

Pg. 123 (Winter bridge)
On occasion, the state will experience a "January thaw"–unseasonably warm temperatures largely due to a surge of warm air, a lack of snow cover and plenty of sunshine. It is rare for the conditions to be perfect

and the pocket of warmth is usually short-lived, but it is always welcomed with open arms by Minnesotans.

Pg. 124 (Ice on pines)

Minnesota has sixteen different species of conifers–trees with evergreen needles that stay on the branches year-round and hold their seeds in cones. A majority of the pines in the state can be found on the eastern side of the Pine-to-Prairie ridgeline, which separates the prairie to the west and coniferous forests to the east.

(Snowmobiles)

Two of the four major snowmobile manufacturers are headquartered in Minnesota. Arctic Enterprises, Incorporated, makers of Arctic Cat, is based in Thief River Falls. Polaris Industries, Incorporated, originated in Roseau, but is now based in Medina. Minnesotans have adopted snowmobiling over the last half century as a family sport. On average, riders will put 1,202 miles on their machines per year.

(Ice on Ten Mile Lake)

The Woodtick Trail begins north of Hackensack near Ten Mile Lake, and winds through Chippewa National Forest. Open year-round, this 14-mile trail was constructed in the 1890s as a railroad grade on which logs were hauled to a Longville sawmill. The trail passes by campgrounds, nature preservation projects, a beaver lodge and crossroads to more trails.

(American Robins)

A small percentage of Minnesota's American Robins do not migrate south if there is a small amount of snow cover, because it is easy for them to find food. If they find an abundance of fruit, berries and insect eggs, they can return to their breeding grounds come springtime before the birds that migrated south for the winter. The early bird will get more than just the worm; the ones that arrive first can then select the best breeding territories.

Pg. 125 (Ice fishing)

When ice freezes on Lake Mille Lacs, another phenomenon occurs. About 8,000 winter icehouses dot the scenery, forming what the inhabitants called the Icehouse Party City. This seasonal community is larger than any other nearby town, except for the Twin Cities area.

(Winter birdhouse)

Most birdhouses remain vacant over the winter months, as most songbirds native to the state will migrate south. Birds that thrive on insects will set-

tle in areas as far south as Central America where their food is abundant year-round.

(Snowy birch)
There are four types of birch trees found in the state: Yellow, River, Paper, and Sweet–the last is the only non-native of the four. Nurseries often recommend planting birch trees for aesthetically pleasing winter scenery because of the unique form they take when covered with snow.

Pg. 126 (Frosty trees)
Early mornings in Minnesota will beckon the use of a camera to capture Nature's enchantment. But don't wait too long; the wind or the sun will easily shake the coats of frost from the trees.

(Heavy icicles)
Though icicles hanging from rooftops are iconic of the natural elegance of winter, artists have the chance to get their hands cold and add to this beauty. A single-block ice-carving contest is held every year at the St. Paul Winter Carnival, bringing in artists from all over the Midwest. The city created this outdoor annual festival when a New York reporter wrote in 1885 that St. Paul was "unfit for human habitation" in winter.

(The cabin up north)
In the state that has over 15,000 lakes, many Minnesotans have found a piece of the shoreline they call their "home away from home." The cabin up North has become a traditional getaway destination of urbanites.

Pg. 127 (Winter catch of panfish)
Though the Walleye is the state's most sought-after fish, panfish like crappies, bluegills and perch are caught the most often. Spring is also a good time of the year for them, since Walleye season doesn't start until May. When the lakes start to warm up, panfish feast on minnows and bugs.

Pg. 128-129 (Snowshoe tracks)
Snowshoes serve the purposes of recreation and mobilization. Because the surface area of the foot is increased, the person will not sink as easily into the soft snow. This allows people to trek through fresh snow to places otherwise inaccessible. Most of the state's summer hiking trails are converted to cross-country ski and snowshoe trails in the winter.

162

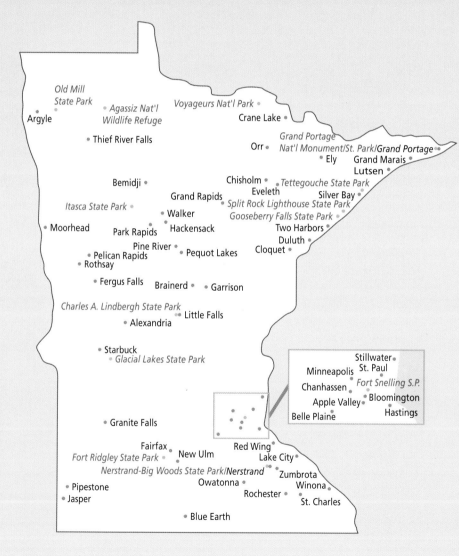

Old Mill
State Park
Argyle
Agassiz Nat'l
Wildlife Refuge
Voyageurs Nat'l Park
Crane Lake

Thief River Falls

Grand Portage
Nat'l Monument/St. Park/Grand Portage
Orr
Ely
Grand Marais
Lutsen

Bemidji
Chisholm
Tettegouche State Park
Eveleth
Silver Bay
Grand Rapids
Split Rock Lighthouse State Park
Itasca State Park
Gooseberry Falls State Park
Walker
Moorhead
Park Rapids
Hackensack
Two Harbors
Pine River
Duluth
Pelican Rapids
Pequot Lakes
Cloquet
Rothsay

Fergus Falls
Brainerd
Garrison

Charles A. Lindbergh State Park
Little Falls
Alexandria

Starbuck
Glacial Lakes State Park

Stillwater
Minneapolis
St. Paul
Chanhassen
Fort Snelling S.P.
Apple Valley
Bloomington
Belle Plaine
Hastings

Granite Falls

Fairfax
Red Wing
Fort Ridgley State Park
New Ulm
Lake City
Nerstrand-Big Woods State Park/Nerstrand
Zumbrota
Owatonna
Pipestone
Winona
Jasper
Rochester
St. Charles

Blue Earth

*M*innesota Parks and Cities Index

Parks

Fort Ridgely State Park .19

Fort Snelling State Park .86, 91

Glacial Lake State Park .23

Gooseberry Falls State Park .66, 67

Grand Portage State Park .70

Itasca State Park .30, 35, 40, 46-47

Lake Agassiz National Wildlife Refuge .19

Lindbergh State Park .29, 37

Nerstrand-Big Woods State Park .102-103

Old Mill State Park . 16-17, 18

Split Rock Lighthouse State Park .62

Tettegouche State Park .60-61

Voyageurs National Park .37

Cities

Alexandria .18

Apple Valley .75

Argyle .16-17, 18

Belle Plaine .88-89

Bemidji .38-39

Bloomington .76, 83

Blue Earth .19

Brainerd .34, 42-43, 48, 50-51, 52

Chanhassen .82, 91

Chisholm .32

Cloquet .30

Duluth .57, 58, 63, 64-65, 66

Ely .44, 45

Eveleth .34

Fairfax .19, 20-21

Fergus Falls .23

Garrison .36

Grand Marais .54-55, 67, 68-69, 70

Grand Portage .70

Grand Rapids .35

Granite Falls .18, 27

Hackensack .49

Hastings .90

Jasper .11

Lake City .98, 105

Little Falls .29, 37

Lutsen .71

Minneapolis74, 76, 77, 81, 83, 86, 91, 94

Moorhead .22

Nerstrand .102

New Ulm .11, 15

Orr .35

Owatonna .104

Park Rapids .30, 35, 40, 46-47

Pelican Rapids .27

Pequot Lakes .48

Pine River .29

Pipestone .26, 27

Red Wing .98

Rochester .99, 105

Rothsay .11

Silver Bay .57, 60

St. Charles .96-97

St. Paul .74, 75, 77, 78-79, 80, 83, 86, 87, 91, 92-93

Starbuck .23

Stillwater .84-85

Thief River Falls .19

Two Harbors .62, 63, 66, 67, 71

Walker .34, 52

Winona .104, 105, 106-107

Zumbrota .98

PRAIRIE GRASSLANDS

- ☐ Old Mill State Park, near Argyle
- ☐ Lake Agassiz National Wildlife Refuge, near Thief River Falls
- ☐ Stavkirke, Moorhead
- ☐ Pelican statue, Pelican Rapids
- ☐ Prairie chicken monument, Rothsay
- ☐ River otter statue, Fergus Falls
- ☐ Big Ole, Alexandria
- ☐ Glacial Lake State Park, near Starbuck
- ☐ Minnesota River, Granite Falls
- ☐ Fort Ridgely State Park, near Fairfax
- ☐ Glockenspiel, New Ulm
- ☐ Pipestone National Monument, near Pipestone
- ☐ Barn south of Jasper on Hwy. 23
- ☐ Jolly Green Giant, Blue Earth

LAKE COUNTRY

- ☐ Voyageurs National Park
- ☐ Voyagaire Lodge on Crane Lake
- ☐ Orr's welcome sign
- ☐ International Wolf Center, near Ely

- ☐ Iron World, Chisholm
- ☐ United States Hockey Hall of Fame, Eveleth
- ☐ Entrance to the Superior National Forest, Laurentian Divide, near Virginia
- ☐ Judy Garland's house, Grand Rapids
- ☐ Lindholm Oil Company Service Station, designed by Frank Lloyd Wright, Cloquet
- ☐ Paul Bunyan and Babe the Blue Ox, Bemidji
- ☐ Jacob V. Brower Visitor Center, Itasca State Park, north of Park Rapids
- ☐ Headwaters of the Mississippi River, Itasca State Park, north of Park Rapids
- ☐ The Red Bridge, Park Rapids
- ☐ Pequot Lakes' bobber water tower
- ☐ Babe the Blue Ox, Brainerd
- ☐ Paul Bunyan, Brainerd
- ☐ Historic water tower, Brainerd
- ☐ Giant walleye near Mille Lacs Lake in Garrison
- ☐ Charles Lindbergh's boyhood home, Lindbergh State Park, Little Falls

DULUTH AND LAKE SUPERIOR'S NORTH SHORE

- [] Aerial Lift Bridge, Duluth
- [] Rose Garden in Leif Erikson Park, Duluth
- [] Great Lakes Aquarium, Duluth
- [] U.S.S. William A. Irvin, Duluth
- [] Duluth's harbor
- [] Canal Park Lighthouse, Duluth
- [] Glensheen Mansion, Duluth
- [] Hawk Ridge Nature Reserve, Duluth
- [] Silver Creek Tunnel on Hwy. 61, near Two Harbors
- [] Lighthouse at Two Harbors
- [] Lower Falls and Upper Falls, Gooseberry Falls State Park, near Two Harbors
- [] Split Rock Lighthouse State Park, near Two Harbors
- [] Silver Bay Marina
- [] Shovel Point, Tettegouche State Park, near Silver Bay
- [] Lutsen Ski Resort
- [] Historic Naniboujou Lodge, Grand Marais
- [] Lighthouse, Grand Marais
- [] Harbor at Grand Marais
- [] Gateway to the Gunflint Trail, Grand Marais
- [] Northwest Company Depot, Grand Portage National Monument

METRO AREA

- [] The Minneapolis Institute of Arts
- [] Historic Mickey's Diner in St. Paul
- [] Lake Harriet Rose Gardens, Minneapolis
- [] University of Minnesota Bridge, Minneapolis
- [] Minnehaha Falls, Minneapolis
- [] Longfellow House, Minneapolis
- [] Holidazzle Parade, Minneapolis
- [] Minneapolis-St. Paul International Airport
- [] Jonathan Padelford Riverboat, St. Paul
- [] Como Park Conservatory, St. Paul
- [] Cafesjian's Carousel, Como Park, St. Paul
- [] Ordway Music Theatre, St. Paul
- [] Minnesota's capitol, St. Paul
- [] Cathedral of St. Paul
- [] Science Museum of Minnesota, St. Paul

- Minnesota History Center,
 St. Paul

- Main gate, Fort Snelling State
 Park, St. Paul

- Andiamo paddlewheel riverboat,
 Stillwater

- The Minnesota Landscape
 Arboretum, Chanhassen

- Mall of America, Bloomington

- Lake Wobegon Store,
 Mall of America, Bloomington

- Entrance to Minnesota Zoo,
 Apple Valley

SOUTHEASTERN MINNESOTA AND BLUFF COUNTRY

- Nerstrand-Big Woods State Park,
 Nerstrand

- Covered bridge, Zumbrota

- Cabela's, Owatonna

- Mayo Clinic, Rochester